At Century's End:
Norwegian Artists and the Figurative Tradition
1880/1990

At Century's End:

Norwegian Artists
and the Figurative Tradition

1880/1990

HENIE-ONSTAD ART CENTER, HØVIKODDEN, NORWAY,
MAY 20 – AUGUST 27, 1995

THE NATIONAL MUSEUM OF WOMEN IN THE ARTS, WASHINGTON D.C.,
OCTOBER 11, 1995 – JANUARY 7, 1996

SCANDINAVIAN AIRLINES

© The Royal Norwegian Ministry of Foreign Affairs, Oslo 1995

Designer: Junn Paasche-Aasen, Oslo

Front cover illustrations:
Kitty Kielland: *Blue Interior with Sitting Woman* (1883) and
Ida Lorentzen: *Only Love's Pleasures Touched My Heart* (1993)

Typesetter: Junn Paasche-Aasen Design, Oslo
Printer: Joh. Nordahl Trykkeri, a.s, Oslo

Printed in Norway 1995

ISBN 82-7177-388-7 (NOR)
ISBN 0-940979-32-2 (USA)

Contents

H.M. Queen Sonja of Norway

FOREWORD

The inauguration of the exhibition *At Century's End: Norwegian Artists and the Figurative Tradition, 1880/1990* marks the start of the Norwegian cultural festivities at The National Museum of Women in the Arts in Washington, D.C. during the 1995 fall season.

The exhibition is devoted to Norwegian women artists of the late 19th and 20th centuries and illustrates how traditions live on in contemporary art. The artists presented here lived and worked in two very different worlds: the position of women, in both the USA and Norway, has changed radically in the course of the century spanned by the exhibition.

The end of the last century was a golden age in Norwegian art, and an era of rising nationalism. Norwegians were in search of a national identity after 500 years of union, first with Denmark and then with Sweden. The painter Edvard Munch, composer Edvard Grieg and playwright Henrik Ibsen are the best known figures of the period. It was a time when women's role in artistic expression was modest and usually limited to creating an attractive home. They had to struggle against middle-class convention in order to gain recognition as professional painters and, if they succeded, they had to conform to a tradition established by male artists. However, their efforts paved the way for later generations. The contemporary artists exhibitied here are outstanding representatives of a generation of women who play an influential and innovative role in the development of art today.

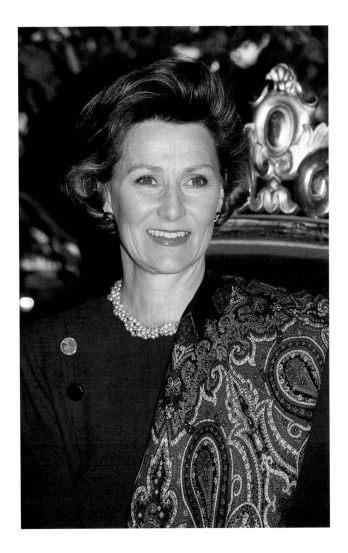

At Century's End: A Feminist Perspective

Susan Fisher Sterling

We are close to the end of our century. Why re-awaken the spirit of the end of the last? Today, women and men in the Nordic countries are more equal than they have been since heathen times. Where, then, do these strange dreams of power and subjection come from?

Gertrud Sandqvist[1]

When we think of the fin-de-siècle, the term conjures up a curious mixture of artistic innovation, personal angst, cosmopolitan ennui and social upheaval. The impression of creative and societal malaise seems unavoidable—as true for the end of the 20th century as it was for the 19th. There is much about the process of reappraisal at century's end that breeds such uncertainties, as we look back on society's accomplishments and failures in the hopes of recognizing and/or influencing what the future will bring. Perhaps, too, it is our overwhelming drive to reach a new plane of cultural understanding and practice that leads to such strong turn-of-the-century ruptures and transformations.

At Century's End: Norwegian Artists and the Figurative Tradition, 1880–1990 posits a distinctive fin-de-siècle link between the late modern and postmodern achievements of contemporary Norwegian women artists and their 19th-century female forebearers. As an exhibition it is meant to engender a certain degree of optimism amidst our angst, for it celebrates, first of all, a development that is different from the usual art historical discussions of style—one which represents an even more fundamental break with the traditions of artistic practice, cultural demographics and the social psycho-

logy of art than was thought possible a century ago. It is a change that has come about in fits and starts across the century's divide, to the point where we now realize that, in the relatively short span of one hundred years, women who become artists are no longer thought of as social aberrants or intellectual freaks of nature. The conceptual coming of age of "the woman artist" which occurred in late 19th-century Europe provided the essential conditions for women's integral participation in the formation and interpretation of late modern and postmodern culture today.

From the 1870s to the turn of the century, it was a matter of women's pushing beyond traditional social boundaries of the day to pursue their artistic goals. The ambition to carve out a respected space for women's work; the willingness to break with traditions of portrait and flower painting to pursue other, more "masculine" forms of expression; the relative freedom to travel, study and participate in national and international art movements; and the attention given to the domestic realm and other spheres of women's social lives as a new and important subject for art, can all be traced to the fin-de-siècle. What began a century ago with a relative few brave women who often took on a male professional guise has become, in the late 20th century, a cultural birthright. With the advent of three waves of feminism, it is now a matter of our looking back through history, determining how women have been socially defined and delimited in art and reformulating the points of that discourse for the future. From Julia Kristeva to Michel Foucault, feminist and postmodernist theory has effectively reoriented

the fundamental assumptions of late 20th-century artistic practice, dispelling paternalistic doubts about women's fitness for artistic work, deflecting the dominion of the male gaze, challenging the dictates of a patriarchal society and, in the process, defining new discursive, artistic and social spaces.

Norway provides a particularly interesting case vis-à-vis women and the arts because the last two decades of both the 19th and 20th centuries have signaled dramatic transformations within that country's socio-political establishment and, consequently, the way in which culture was and is created, categorized, discussed and valued. Not surprisingly, women have been integral and instrumental participants in those periods of intense realignment.

In the 1880s, for example, for the first time in its history, Norway developed an art scene which was suddenly contemporary with the rest of Western Europe. As Magne Malmanger has written, from the late 1870s through the early years of the new century, Norway's leading artists chose to settle in their homeland and find their place as an integral and influential part of society. Whereas earlier generations had found Düsseldorf, Dresden and Munich more commodious to their ambitions, by the 1880s, with nationalist fervor running high throughout Europe, Norway's cultural milieu fostered an intellectual homecoming that was crucial to the development of what has been called "the golden age of Norwegian painting."[2]

Harriet Backer and Kitty Kielland, as well as Asta Nørregaard, were the most important among numerous women who participated in Norway's invigorated late 19th-century art scene,

as Anne Wichstrøm documents in her catalogue essay. While most foreigners' views of fin-de-siècle Norwegian society have been strongly colored by Edvard Munch's and Henrik Ibsen's images of late Victorian sexual and social repression (for women as well as for men), the cultural elite of Kristiania (now Oslo) actually offered an unusual blend of provincial and cosmopolitan values, national and international interests. No doubt the social space women inhabited was narrow, but perhaps no more so than in Vienna, Berlin, New York or Copenhagen. As middle-class and upper-middle-class women who had been willing to leave their homeland for the increased freedom of Munich and, especially, Paris's art schools, Backer, Kielland and Nørregaard profited from the opportunities available. They returned from their fifteen years in Paris with training from the Académie Julian and the Académie Colarossi and full knowledge of the work of salon realists such as Jules Bastien-Lepage and symbolist Pierre Puvis de Chavannes, as well as impressionists Edouard Manet and Claude Monet. They had sketched and painted at popular artists' watering holes from Brittany to Provence, maintained acquaintances with artists from Scandinavia and elsewhere in Europe and sold their paintings, mostly to Norwegians of the new haute bourgeoisie. In Paris, their artistic interests led them each, in their own way, to paint interior scenes of "modern life." Rather than follow traditional academic styles, they, as realists, sought to convey their lives in the studio, the parlor and other social spaces which were the domain of women, along with their work, as directly as possible.

Bound by age, friendship and, to a certain degree, by their sex, these three artists returned to Norway at the peak of their careers and contributed integrally to an artistic dialogue which defined the sum and substance of fin-de-siècle Norwegian painting. Backer and Kielland, in particular, were part of a circle of artists headed by the charismatic Erik Werenskiold who hoped to define, even create, a new and demonstrably Norwegian culture.[3] Following the precepts of realism, they believed that a truly Norwegian art could be formed from the faithful observation of the country's people and landscape.[4]

In asserting this point of view, they turned against the aesthetic values and nostalgic symbolism of their German-trained predecessors for the first time in their country's history. The heated debates in the mid-1880s at the Kristiania Art Society over the efficacy of realism's documentation of contemporary Norwegian life led the country's first art critic, Andreas Aubert, to declare: "The new Norwegian art of painting is born with the new Norway. Our freedom, our constitution has the same origin."[5] Although Norway was not to achieve nationhood until 1905, its aspirations to that end were championed by its native sons—and daughters.

Debate occurred within their own generation as well, as Werenskiold, Backer and Kielland defended their artistic intentions against attacks from "the Bohemians," a group of internationalist writers and artists led by the accomplished artist/critic Christian Krogh. As outspoken theorist for this group, Krogh's famous polemic, "All national art is bad, all good art is national" was a pointed rejection of their nationalist program.[6] Instead, "the Bohemians" emphasized the importance of individual experience, including the plight of the downtrodden, over nationalistic concerns, a viewpoint which encouraged Krogh's young protégé Edvard Munch.[7] In Kristiania during this era of cultural controversy and intense nation-building, the founding of the Autumn Salon in 1882 (a Salon des refusés, like its predecessor in Paris) gave space to all dissenting artistic voices, the establishment of a national gallery of art provided a measure of the new social power held by the Norwegian art scene, and the country's new liberal parliament met for the first time in 1884.

While Backer, Kielland and Nørregaard's early work from Paris concentrated on the interior as a registration of the female sphere, the resemblance between their artistic interests grew weaker in time. In large part, this was conditioned by Backer and Kielland's conscious decision to dedicate themselves to representing national particularities in the avant-garde styles they had mastered in Paris. Informed by plein air realism and impressionism, Backer concentrated on refining her light-filled, highly colored interiors depicting working women and men, along with her especially sensitive portrayals of the simple life and rituals of the Norwegian church. Kielland, for her part, chose to concentrate on the unladylike genre of landscape painting, describing again and again the windswept bogs of her native Jæren with an earnestness that may have equaled Monet's concentrated vision at Giverny. Often striking a moral chord, as each pursued inherently Norwegian subject matter throughout the 1890s, Backer and Kielland established themselves as pre-

eminent painters of their era. Nørregaard, who, by choice or circumstance became more of the outsider, established herself as the premier portraitist for the Kristiania elite.[8] Her preference for pastel in representations of women and children was, however, an interesting choice, similar or perhaps even related, to American Mary Cassatt's predilection for pastel renderings of the same subjects.

As the century turned and throughout the years preceding World War I, these artists and their compatriots were enshrined as important participants in the fundamental transformation of Norwegian painting. Typically and ironically, the progressive fin-de-siècle ideals they had brought to bear on Norwegian art became entrenched ways of seeing. As the 20th century progressed, Norwegian artists' preference for or proclivity toward painting the figure and the landscape became a measure of their independence from internationalist trends. Such figurative art was seen by many as a badge of honor and a source of national identity against an onslaught of foreign ideas. Others, such as Malmanger, characterize this period as "the progressive provincialization of Norwegian culture," as the artistic dynamism at century's end was slowly dissipated by successive generations.[9]

As Toril Smit has set forth in her catalogue essay, Norwegian art continued to develop along this line of largely internal references. This trend reflected Norway's position at the periphery of Europe, its value system which emphasized figural and narrative accessibility of art and a strong desire to maintain a national cultural identity. Art "isms" from abroad were accepted, but often belatedly and only if they could be adapted to the Norwegian art consciousness. Abstract expressionism, which was adopted by a post-war generation of artists which included Jakob Weidemann, Irma Salo Jæger and Gunnar S. Gundersen, was not accepted by the dominant art circles until the 1960s. Throughout the 1970s, minimalism, conceptualism, earth art, large-scale installations, performance and video art languished almost unnoticed, with the significant exceptions of work by Marianne Heske, Bård Breivik and Gerhard Stolz. As Per Hovdenakk recalled in his 1986 article, "Norwegian Art Opens to the World," the so-called international "exile of painting" from 1965 to 1980 under the influence of these new artistic concepts did not occur in Norway. Instead, the 1970s was characterized by national isolation, as art and society moved in different directions along a socialist model.[10]

In what Norwegian art historian and critic Jon Ove Steihaug characterizes as a paradox, Norwegian art became "international" once again during the 1980s in perhaps the only way possible—under cover of a regional, specifically "Nordic" identity.[11] This exotic other-ness was "discovered," for example, in the neo-romantic paintings of Odd Nerdrum, who continues to be Norway's best-known contemporary artist. Like much of German neo-expressionism, it was the angst-filled imaginings of the Norwegian past rather than his recognition of its present that led to Nerdrum's popularity. While many saw this art as *retardataire* historicism, the attention he received in Germany and elsewhere in Europe did serve to open Norwegian eyes to new possibilities for cultural acceptance outside of Oslo, Bergen and Trondheim.[12] As

the 1980s progressed, increasing numbers of Norwegian artists once again began living, studying and exhibiting abroad—in Berlin, Cologne, Maastricht and New York—and returned home with a wealth of new interests. Combined with today's rapid flow of cultural information, a broader context was established in the 1980s and 1990s which all but erased the boundaries between "peripheral" Norway and the art centers of Europe and the United States.[13]

Once again, at the end of the 20th century, numbers of Norwegian artists have found themselves in step with international developments and, concurrently, at the center of new and acrimonious national debates such as have not been experienced since the 1880s. Whereas at the end of the 19th century, artists returned home from abroad with ideas that led them to promote a new, soon-to-be national identity, now, at the end of the 20th century, artists are returning home to promote Norway's participation in what is quickly becoming a global cultural scene. At the end of 19th century, the country's cultural polemics, in step with its socio-political goals, centered around the creation of a new, demonstrably Norwegian culture. Now, at the end of the 20th century, in art once again as in politics, a strong social and ideological shift is underway as Norway considers and reconsiders its entry into the international community.[14] As Trond Berg Eriksen stated in 1992, "Norway has been a closed world, whilst Europe is an infinitely manifold universe. Today's circumstances provide no absolute truths, but on the contrary more partial perspectives. We must, therefore, not only

learn to understand our culture as European, but begin to think differently about what a culture can be."[15]

In this charged atmosphere of reexamination and realignment, many of Norway's assumptions about late 20th-century art are being scrutinized and debated, from the state system of support for the arts to the definition of what art should be. Unlike any other country in the world, in 1978 Norway's social democratic government instituted a system of monetary support for its artist-workers. Support includes the payment of a minimum income to over 250 artists per year based on state commissions and purchases. Additional support is provided through exhibition fees and opportunities via regional artists' centers, national organizations, such as the Landsforeningen Norske Malere, Norske Grafikere, Norsk Billedhoggerforening and Tegnerforbundet, and the yearly Autumn Salon, which has continued since 1882.[16] Women as well as men have benefited from this system and number over fifty percent of all art educators in Norway.[17] Yet, despite this substantial attempt at social equity, since the mid-1980s the artist system has experienced increased criticism from those who question its guild-like mentality, bureaucratic structures and reticence to understand and embrace media and practices other than painting, sculpture and the graphic arts. As Jon Ove Steihaug has explained, the preeminence of Norwegian painting, with its strong expressive gesturalism or neo-romantic attitudes and emphasis on virtuoso craft, is being confronted by the emergence of "other techniques," a catch-all phrase for alternative practices from conceptual and postmi-

nimalist art to postmodern photography, all of which point to a strong and steady influx of international influences.[18]

This state of affairs has affected many young artists, women particularly, for in Norway, as in other countries, it is often women artists who are breaking new ground in alternative media and practices. One can see this in the demographics of the contemporary artists represented in this exhibition: Ida Lorentzen and Hanneline Røgeberg are painters whose work serve very different ends; Kristen Ytreberg is a former architect who creates installation sculptures using lead, zinc, cloth and found objects; Marianne Heske is a conceptual artist who creates installations using large-scale photographic blow-ups of video-based imagery, often combined with manufactured and/or found objects; Line Wælgaard is a postmodern photographer; and Hege Nyborg employs painting, drawing and slide projections to create her postmodern commentaries.

When subject matter and artistic intentionality is considered as well, it becomes clear that these women, like their fin-de-siècle predecessors, are involved in reinventing figuration as part of new set of criteria and influences that are distinctly late modern and postmodern.[19] Their reconsideration of such 19th-century genres as landscape, interiors and history paintings would never have been thought possible in Norway twenty years ago, but are here again being practiced in a new guise. As they grapple with the past, these artists maintain a vestige of their Norwegian figurative origins, while they also are forging new paths out of abstraction that began in the 1970s with the

advent of conceptual art, feminist theory and postmodernism.[20]

There is a strong theoretical and psychological component to this contemporary work, as these artists wrest their figures, landscapes and interior scenes from the traditional perspectives to assert a new vision. Although each of the artists maintains a relationship to objects in the real world, theirs is a very different vision from the direct observation of nature that was the primary foundation of the 19th-century realism practiced by artists such as Backer, Kielland and Nørregaard. Even the works that appear most literal in their transcription, such as Ida Lorentzen's paintings of her studio interior, are replete with instances of opacity and obfuscation, remoteness and self-reflexivity. These are worlds physically, theoretically and psychologically transformed by late modern or postmodern concerns: parallel universes, unfamiliar territories, historical disjunctions that often leave us wondering. While the imagery is familiar, the works do not reveal the artist's perspective or other secrets easily.

Lorentzen and Ytreberg, for example, create domestic interiors in which the viewer has difficulty determining his/her place. Populated by doors, gates, tables, beds, mirrors and other odd, assorted furnishings, these rooms create a cool, abstracted, dreamlike claustro(phobia), similar to that of a Samuel Beckett play. They allow one to enter, visually in the case of Lorentzen's paintings, physically in Ytreberg's minimalist installations, yet they feel more like antechambers than actual, living rooms—they are spaces where one awaits answers or an action. The traditional view of the comfortable

domestic interior as a woman's space, in which reading, sewing, music or letter writing occurs, has been transformed into a psychologically charged simulation, where no action takes place except for that provided by the viewer. The interior becomes a metaphor for interiority —the carving out of a mental space which becomes a symbol of the self—a virtual reality which is ultimately unknowable in its full dimensions. This is as far from late 19th-century realism and its positivist roots as one might hope to get.

While Lorentzen and Ytreberg concentrate on interiors, Marianne Heske's installations bear a relationship to the long history of Norwegian landscape painting. (The artist even felt comfortable suggesting that her work be installed in the same gallery with that of Kitty Kielland.) Yet, in her video-based visions from *Landscapes of the Mind* and *Voyage Pittoresque* to *Avalanche*, the power and grace of nature, so important to previous generations of artists, is no longer seen as reason enough to record it. Or, perhaps more correctly, Heske perceives that the energy and history of the Norwegian landscape and its imagery are constantly mediated by human views and concerns—a concept which she makes explicit in her oeuvre. Using photographic blow-ups of video images of mountains and other scenes which she has manipulated onscreen, her pixelated landscapes are many times removed from the visual data originally supplied by our neural receptors. Nature, transformed through this new neural net, becomes a reflection of shifting human values and encroachments over time. Moreover, in her more pessimistic moments, Heske's

landscapes can become a psychologized metaphor for human catastrophe—when oversocialization becomes dangerous to the individual's natural mindscape.[21]

Like Marianne Heske, a younger generation of artists including Hanneline Røgeberg, Line Wælgaard and Hege Nyborg also are concerned with the natural/social construction of vision and identity, although their interests center around the need to assert and support new cultural definitions of female identity and gender. In pursuing this feminist and postmodern theoretical line, they deliberately co-opt the academic genres of figure and history painting, traditionally practiced by men only, to effectuate their goal of redefinition. In doing so, each artist attempts to create a space for her female protagonists which refutes, deflects, confuses or veils the eroticization normally associated with depictions of the nude throughout the history of art.

Røgeberg's paintings consist of monumental, often somnambulant, female nudes engaged in lifting or holding one another in a studio or a landscape that is strangely reminiscent of Kielland's turf at Jæren. While the form of the paintings is reminiscent of 19th-century salon realism, the de-aestheticization of the women's faces and physiques and their unexpected, only partially explained, physical interactions and environs defy convention and nullify the titillating objectification that normally occurs in such works. Female-to-female relationships and an almost essentialist identification of these women with the landscape are important in these resolutely non-linear, nonnarrative paintings. Because no recognizable

storyline or myth is offered by the artist, her paintings tacitly refute the patriarchal precepts of female sexuality, as well as the normative precedents of history painting.

While Røgeberg's paintings reorient the relationship between female figures and nudity by avoiding traditional narrative schema and other conventions of history painting, Line Wælgaard and Hege Nyborg's art exposes gender issues implicit in the patriarchal canon of art history by re-presenting earlier works of art in ways that expose and transform their original value systems. Wælgaard's photographs consist of staged figural *tableaux vivant* in combination with appropriated historical and contemporary images. Treated with the slickness of magazine glossies or Duratrans advertisements, her subjects include a close-up of Giotto's *Lamentation*, a paraphrased triptych of St. Agathe or a recasting of the play of hands in Michelangelo's Creation cycle. Most often, her choice of subject and juxtaposition of imagery is meant to refocus attention on the way in which women's lives—as archetypal mourner, martyr, mother and sinner—are or should be represented in the history of art. Ultimately, on a deeper level, however, these works disrupt the historical sanctity of their religious precedents, providing alternative postmodern readings for a generation whose faith is nonexistent or in serious doubt.

Of these three artists, Hege Nyborg's art is the most confrontational. It is also, by intention, the most difficult to grasp in its revisualization of paintings and other historical "documents" as vehicles for and symbols of patriarchal dominance. Well-versed in feminist and postmodern theory, the artist combines appropriated imagery and texts from a wide range of sources to illustrate, disrupt and overturn the objectification and subjugation of women by the voyeuristic, male gaze.[22] As she adroitly paraphrases and recombines the likes of François Boucher's 18th-century boudoir nudes and André Le Nôtre's gardens at Versailles with passages from Jean-Jacques Rousseau's *Confessions* in her diptych *In the Garden of Eden*, or recharacterizes Jean-Martin Charcot's 19th-century photographs of female asylum inmates and Marcel Proust's text from *Remembrance of Things Past* in serialized drawings for *Attitudes Passionelles*, she lays bare the social constructs which have shaped feminine identity in the past and continue to play on changing notions of female selfhood today. Like artists such as Mary Kelly, Dottie Attie and Cindy Sherman, Nyborg's works have a stiletto sharpness that cuts through centuries of sexualized portrayals of women by male artists, writers, psychotherapists, theologians, philosophers and others to reveal the inequity of the social contract and "mankind's" subordinating cultural subconscious. To rephrase Gertrud Sandqvist, Nyborg's art provides a new empowering twist to Freud's famous thesis, "that which is repressed returns with redoubled force."[23]

With Hege Nyborg's *Attitudes Passionelles*, we return not only to the 19th century, where our discussions of "the woman artist" first began, but also to Sandqvist's question about bringing up the issues of past when dealing with the present. That question should be somewhat easier to answer now. Having bridged 19th- and 20th-century fin-de-siècle cultures in

this essay, we recognize not only how far women artists have come in a short period of time, but, how, like our 19th-century predecessors, we continue to mine the past for that which we need—a link, a break, at times an undefinable mixture of ideas and events that transforms our most entrenched cultural and socio-political attitudes. If we grant that the international art scene is in a state of flux as we experience a tortuous and uncertain detachment from modern artistic and societal norms, it may be important to remember that the roots of 20th-century modernism were to be found in the confusing upheavals of late 19th-century fin-de-siècle culture. If, like the artists in the current exhibition, we are willing to be optimistic about the viability of our cultural enterprise during the transformations of the late 20th century, then we may be able to envision a time when late modern and postmodern art will have provided the generative seedbed for a similar efflorescence in 21st-century artistic life.

NOTES

1 Gertrud Sandqvist, discussing the work of contemporary Norwegian artist Hege Nyborg, in "A Whole New Generation," *Siksi* (April 1994): 5.

2 Magne Malmanger, *One Hundred Years of Norwegian Painting* (Oslo: Nasjonalgalleriet, 1988), 7–8.

3 Other artists in this nationalist circle included Eilif Peterssen, Christian Skredsvig, Theodor Kittelsen and Gerhard Munthe.

4 As Robert Rosenblum has observed, "the pull of documentation, of recording the visible facts of people, places, social life persisted throughout the later nineteenth century . . . in the more high-minded domain of creating a nationalist art that would reflect not the generalized truths of a pan-European tradition but the specific experiences of a Western world that spread over five continents . . . Another kind of response was found in the expansion of landscape painting to accommodate what was to become a global urge to record the geographic facts and beauties of those countries which were eager to be counted in a growing community of Western nations." See Robert Rosenblum and H.W. Janson, *19th-Century Art* (New York: Harry N. Abrams, 1984), 381–382.

5 Olga Schmedling, "Christiania—Revival of a Capital's Cultural Center," *Kunstårbok 1992* (Oslo: KIK Center for Contemporary Arts and Crafts), 23.

6 Trond Berg Eriksen, "What Is National Identity?" in *Kunstårbok 1992* (Oslo: KIK Center for Contemporary Art and Crafts), 19

7 Malmanger, *One Hundred Years*, 16–17.

8 Nørregaard, who, like Backer, had no independent means of support, may have begun taking portrait commissions as a source of income. The occasional plein air garden or churchyard scenes created after 1890 demonstrate her continued skill and proficiency with other genres.

9 Malmanger, *One Hundred Years*, 8.

10 Per Hovdenakk, "Norwegian Art Opens to the World," in *Borealis* (Berlin: DAAD Galerie, 1986).

11 Jon Ove Steihaug, "NACAAP – Norwegian Art Contexts and Alternative Practices," *Siksi* (April 1994): 38.

12 One could, for example, draw a parallel between Nerdrum's virtuoso history paintings and Eilif Petersen's late 19th century historicist treatment of Norwegian legends and archaic past.

13 Steihaug, "NACAAP – Norwegian Art Contexts," 38.

14 Steihaug, "NACAAP – Norwegian Art Contexts," 38. Jon Ove Steihaug sees culture as one of the key commodities of international exchange during this period of uneasy fin de siècle shift. He characterizes the past fifteen years as a distinctly internationalist phase in Norway's history, in which its goals as a nation and its cultural perspective are in a mode of intense reexamination and readjustment. Citing debate over the European Union, the increased presence of immigrant and migrant worker populations, the social democra-

tic welfare state's subjection to pressures of market liberalism and the instability of nearby Russia and Eastern Europe, Steihaug believes that the Norwegian bedrock is shifting as the nation moves away from its homogeneous, nationalist and often isolationist past.

15 Eriksen, "What Is National Identity?" 19.

16 This information was gathered from Per Hovdenakk, "Norwegian Art Opens to the World," in *Borealis* (Berlin: DAAD Galerie, 1986), and Jon Ove Steihaug, "Other Techniques: An Alternative to the 'Norwegian Painting,'" in *Kunstårbok 1993–94* (Oslo: KIK Center for Contemporary Art and Crafts), 85.

17 See Toril Smit's catalogue essay for a brief discussion of the earnings and recognition gap between women artists and their male counterparts.

18 See Steihaug, "Other Techniques," 85–95. In response, artists are often choosing to bypass the state-supported system in favor of alternative galleries such as Oslo's Herbslebs Gate 10 and the artist-run Young Artists Association (UKS). See also Steihaug, "NACAAP – Norwegian Art Contexts," 38.

19 Several artists in exhibition, including Hanneline Røgeberg and Marianne Heske, commented with pride and interest on being linked with their female predecessors from the 19th century.

20 At its core their art may be seen as a tangible challenge to the "Nordic" exoticism practiced by Nerdrum and others since the 1980s.

21 In addition to video-manipulated photographs, Heske often uses found and manufactured objects in her installations, including an old Parisian Kewpie doll's head, which has been a part of her work since 1970s. While Heske's views are not overtly feminist, this commonplace, empty-headed doll is one of her enduring symbols for humankind. Perhaps the artist's alter ego, Heske has given her doll a brain, by transposing phrenological zones onto its surface, and, more recently, an anima, by placing a bit of colored glass at the core of its head, now fashioned in crystal.

22 See Toril Smit's essay for a discussion of Nyborg's appropriations, from François Boucher's painting of Hercules and Omphale and Jean-Jacques Rousseau's *Confessions* for her work *In the Garden of Eden* (1992) to Jean-Martin Charcot's photographs of female asylum inmates and Marcel Proust's *Remembrance of Things Past* for *Attitudes Passionelles* (1994).

23 Sandqvist, "Whole New Generation," 5.

At Century's End:
Harriet Backer, Kitty Kielland, Asta Nørregaard

Anne Wichstrøm

THREE INTERIORS

In 1883 three Norwegian women studying art in Paris painted interiors that reflected on their lives as women in the private sphere and as artists in the public arena. Each artist handled the interior in a separate manner.

Harriet Backer's (1845–1932) *Blue Interior* is the most domestic of the three. The elegant bourgeois parlor she portrayed was not her own, but that of a Parisian acquaintance. Backer must have selected it for its painterly qualities—the furniture, the colors and the light. The center of interest is the woman sewing, but the interior is much more than a neutral backdrop; it lives and breathes. The painting's focus on the relationship between form and content signifies an important stage in the coloristic liberation in which Backer was engaged at this time. An exhibition of paintings by Claude Monet had made a strong impression on her. After that, she thought all other paintings seemed colorless. At the same time, she was developing her own technique based on disciplined composition and solid drawing; color came along as a gift. She described her approach in striking words: "With disciplined drawing, every speck of color in the proper place. The particles of color must be placed in unwavering constellations, the way the stars are arranged in the heavenly constellations and blink at each other, the way musical chords sound together absolutely beautifully in chromatic harmony."[1] The content of the painting is conventional. Women painters, in particular, often chose subjects from the domestic sphere, a female world that they could depict

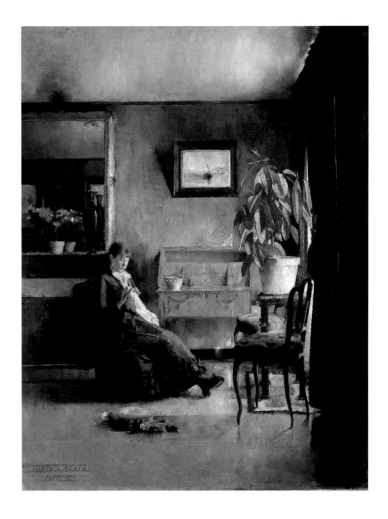

HARRIET BACKER
Blue Interior (1883)
Oil on canvas, 33 x 26 inches
The National Gallery, Oslo, Norway
Photo: J. Lathion, The National Gallery, Oslo

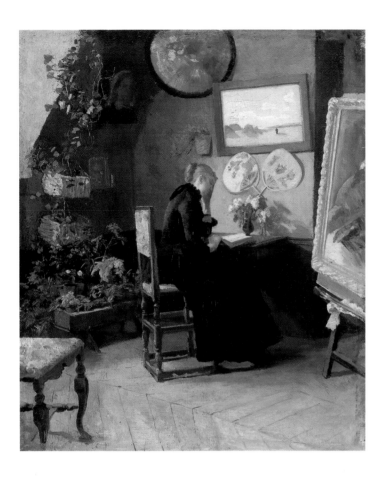

KITTY KIELLAND
Studio Interior, Paris (1883)
Oil on canvas, 16 ¾ x 14 ½ inches
Lillehammer Art Museum, Lillehammer, Norway

expertly. What is intriguing about this painting is that the model is her colleague and friend Asta Nørregaard, who appears not in her capacity as an artist but in a traditional female role—casually reclining, her sewing in hand.

Harriet Backer was herself the subject of Kitty Kielland's (1843–1914) *Studio Interior* (cat. 8), which depicted their shared attic apartment at 19, rue de l'Université. This painting is completely different from *Blue Interior*. The living room, or the section of the room that we can see, is small and cramped. But it is intimately and comfortably furnished with green plants, oriental fans and parasols on the wall, along with one of Kielland's landscape studies over the desk, where Harriet is sitting absorbed in a book. On the easel to the right is a large, unfinished portrait of Kitty that Harriet was painting the same year, so both artists are present in the work. It is both an intimate domestic scene and a studio workplace, the center of Backer's and Kielland's activities as artists in Paris. The painting conveys an impression of activity, an awareness of that which was considered modern and an atmosphere that is intellectual. Kielland applies the principles of plein air painting—the colors are pure, the light is clear and, to a greater extent than Backer, she devotes herself to detailed observations of individual objects.

Asta Nørregaard's (1853–1933) *In the Studio* (cat. 16) conveys no domestic coziness—the atmosphere is purely professional. The painting is reminiscent of an old-fashioned portfolio piece. Nørregaard places herself in her studio in Paris, where she is looking at her finished commission, the altarpiece for Gjøvik Church. Though small and spartan, the studio contains the essentials:

easel, paint box, brushes and a large palette. The painting demonstrates breadth and competence. Nørregaard has mastered an academic conception of a room, the handling of the light and the presentation of a human figure—all the elements of painting, in fact, from the classic still life (the paint box) to the techniques of the impressionists used in creating the autumn foliage outside the window. She knows the old masters—a copy of Titian is on the wall—and the altarpiece shows that she is in command of religious painting, which still enjoyed high status in salon circles. She is also ready for portrait commissions—in the right-hand corner a chair covered with a drape is prepared to receive models. The painting is a remarkably self-conscious demonstration of professionalism, revealing a positive, even aggressive attitude. At the same time, however, the studio has a severe, almost isolated feeling. The artist seems enclosed in a constructed room; the shut door and the crossbars on the window evoke a prison. Freedom is outside, and loneliness is the price she pays for painting.[2]

There is no common plan behind the three paintings; it was probably just a coincidence that they were painted during the same year in the same city by three artists who were friends. Nevertheless, they can be viewed as illustrating various aspects of the woman painter's existence—the traditional female role in the private sphere, the independent intellectual and the professional self-promoter. In a sense, all three paintings and their creation cast light on the liberation of women, their emancipation and, particularly, their status as professional artists. Emancipation and professionalism were important themes at the end of the 19th century.

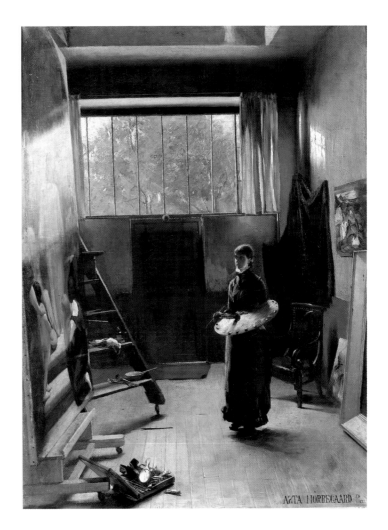

ASTA NØRREGAARD
In the Studio (1883)
Oil on canvas, 25 ½ x 19 inches
Private collection
Photo: O. Væring, Oslo

Kitty Kielland, Harriet Backer and Asta Nørregaard were beginning their careers in 1883. Fifteen years later, at the very end of the 19th century, they were at the apex—mature, well-established and highly respected. As female pioneers, they had struggled for their careers, and they had won. Paintings exhibited in the Paris salon, honors, acquisitions by public collections, sales and commissions were proofs of their success. They were among the most prominent painters of the great generation of the 1880s in Norway. Backer and Kielland always have been included in the literature of Norwegian art history.

Toward the end of the 1890s the varied repertoire and diverse artistic activity that had marked the early careers of these three painters was replaced—to a certain extent and in varying degrees—by specialization and consolidation in style and theme. Harriet Backer painted her beautiful church interiors, most often using religious ceremonies as the focal point. The best and most important of Kitty Kielland's landscapes expressed spirituality in a different way, through slightly stylized, atmospheric representations with symbolic overtones. Both painters were anchored strongly in realism and nationalism, but their art took up new trends with originality and confidence. Asta Nørregaard was also a realist, but her art took another direction. She painted fashionable portraits of the upper class that have an international orientation, but lack the grounding in national values that characterizes the work of the other two painters.

These mature paintings vary considerably in theme and style. All evidence an awareness of art trends at century's end, but express this awareness in different ways. How did the three artists react to the new impulses of the day? Did they influence each other's work? How was it possible for the three of them to break with what could be called a normal female career path? What battles did they have to fight? How do their careers compare with those of male artists? These are but a few of the questions that their mature works evoke.

The interplay of emancipation, professionalism and femininity is key to understanding the work of these women. Superficially, one has the impression that these three artists are taking on "male" careers, yet each of them, and Kielland in particular, is keenly aware of herself as a woman artist. As artists, they do not dismiss their gender but rather reflect on it. Rich source materials make possible a multifaceted examination of Backer's and Kielland's relationship to art and femininity. Source materials for Nørregaard are more limited, but what we know about her career still provides a basis for tentative conclusions regarding similar aspects of her work.

The three artists had more or less the same background socially, culturally and educationally. Their lives were intertwined. But while they shared many traits, their distinctive personalities set their artistic development along different courses.[3]

Compared to other Western countries, the prerequisites for becoming an artist in Norway were unique. Norway was a young country culturally. Four hundred years of Danish rule separated the cultural and political independence that had characterized the region early in its history from the fumbling young nation created in 1814. In the Middle Ages, Norwegian artists had produced outstandingly original works of architecture and visual art, primarily using wood—in stave churches, sculpture and painting. During the four hundred years of Danish rule (known in Norway as the Four-Hundred-Year Night), there was no support for high culture in Norway. There were virtually no cultural institutions, no art schools or academies, no permanent exhibitions, no art criticism or literature. A weak Danish upper class could not safeguard Norwegian cultural concerns, nor was it particularly interested in doing so. The region's few professional artists, primarily portrait painters, were either Danish in origin or became Danish. But traditions from the Middle Ages continued to flourish among the Norwegian peasant classes, mixing with continental and urban trends to create an original folk art in wood carvings, paintings and textiles. This art did not attract significant attention until the end of the 19th century, during the period when the three painters that are the subject of this essay were at the height of their careers.

In 1814, as a result of the Napoleonic wars, Norway split away from Denmark, acquired one of the most radical constitutions in Europe and formed a union with Sweden that lasted until 1905. A new society was to be established, based on a democratic form of government and a theory of social equality. Involvement in the cultural sphere was strongly encouraged as the new nation deliberately set out to create an independent national culture. In the face of economic difficulties, however, the work proceeded slowly.

The leaders of the new Norway began with the very basics. Those few institutions that existed had been developed meagerly. There were only a handful of artists representing the visual arts, and most of them were living abroad. For most of the 19th century, in fact, Norwegian artists were relegated to foreign academies and educational institutions, the most important of which were in Dresden, Düsseldorf, Munich and Paris. There, artists received solid training to the extent that they could afford it. For many, their studies were all too brief. Others spent a long time abroad—some their entire lives—but separation did not prevent them from creating a Norwegian culture and a Norwegian school of painting.

The earliest and most prominent example of such an expatriate artist is Johan Christian Dahl, a professor in Dresden who has been credited with discovering the Norwegian landscape—expressed in meticulous studies of Norwegian mountains and fjords, coupled with a German romantic tradition. The Norwegian artists living abroad shared the joy of discovering Norwegian nature and culture, which came to dominate their art. These impulses were particularly strong toward the end of the century, although by then Norwegian artistic expression also began to take other forms.

The first art associations were established

in Norway in the 1830s. The first painting school supported by the state opened in 1859. Although Norway did not have its own art academy until 1909, an artistic and institutional breakthrough occurred during the 1880s. The higher goal was to create a Norwegian art in Norway, to express what was uniquely Norwegian, above all through the choice of Norwegian motifs. At the same time, various currents from abroad, such as realism and impressionism, were making an impact. A large group of socially involved young artists deliberately undertook a project of artistic consciousness-raising. They established themselves in Norway and took the lead in creating new institutions, such as their own juried art salons—the State Art Exhibition, known as the Autumn Salon—and their own union. A market for art developed. Key names on the art scene in these years include Christian Krohg, Erik Werenskiold and Edvard Munch.[4]

In many ways, of course, the lack of an artistic tradition and established art institutions was a disadvantage for the artists and their audiences. But the situation also presented some advantages, such as the absence of rigid conventions and the opportunity to create institutions according to their own inclinations. The artists were young and radical, as were their paintings and the institutional framework in which they worked. For women, it was a time of opportunity.

Opportunities for Women Artists

In Norway and throughout the Western world, the technological and economic transformations of the 19th century were changing the situation of women. Technological advances, the emergence of the bourgeoisie and the development of a new monetary economy liberated women from domestic tasks and opened up opportunities for other types of work and for education—within the limits set by attitudes regarding women's abilities.

Art played a special role in these economic and social changes. European tradition had long supported artistic efforts by women, both as amateurs and as professionals. Art was well suited to what were considered to be women's distinct capabilities. Dedicated to beautifying life for their husbands and children at home, women were the recognized experts in aesthetics. They drew, painted and embroidered. Women who wished to become professional artists could build on these established activities. At the same time, however, they confronted limitations imposed by entrenched conventions.

From the Renaissance on, professional women painters had been, almost without exception, the daughters of artists. The best opportunities for artistic training were to be found in a father's (or brother's) studio or workshop. The conditions still pertained in the 19th century, but women artists were no longer primarily artists' daughters. Norway was even more open than other nations in this regard, for in this new nation the painting profession was so newly established that even by mid-century there were hardly any artists with daughters who had reached working age.

In Norway more than sixty women exhibited in the public art arena before 1900.[5] First appearing around 1850, their numbers gradual-

ly grew, reaching a high point in the 1880s. These women painters shared an astonishing number of socio-cultural characteristics. They were daughters of the civil servants and the merchant bourgeoisie and, with few exceptions, were unmarried (those who married stopped painting). In bourgeois circles aesthetic accomplishments and cultivated tastes were considered beneficial to a young girl's future home and family, and these women had been encouraged to engage in artistic activities while young. Eventually all of them went out in public with their sketchpads, easels and paint boxes. Those who showed talent and who had liberal parents were allowed to perfect their skills by attending art school or by studying under an established artist. Most also spent a short time at a foreign art school. Then came participation in group exhibitions, commissions and sales, but only in exceptional cases were these extensive enough to provide the means for independent living.

Many lived long lives as artists, but their activity dwindled with age and they became less visible. They led quiet, unobtrusive bourgeois existences amid circles of women, in which mothers, sisters, nieces, aunts, female friends and colleagues were closest to them. They chose "suitable" and conventional subjects—portraits and images from the domestic sphere—and they complied with the leading aesthetic ideals. In all these ways they were much like the women painters in other Nordic countries in the late 19th century,[6] as well as those in Europe and the United States.

But Norwegian women artists had an advantage in having access to art institutions that were so young and radical. There was no tradition of excluding women, so women participated from the very beginning. Nearly a third of the exhibitors in the Autumn Exhibitions of the 1880s were women. Men artists, too, had a radical image to uphold and could not very well discriminate, at least not openly. The Norwegian Women's Rights Association, founded by middle-class women in 1884, also exerted a certain amount of pressure and helped legitimize women's professional ambitions.

These were the conditions in which Harriet Backer, Kitty Kielland and Asta Nørregaard began their careers. They were the most successful of Norway's women artists, for reasons I will consider later. Of course talent is the fundamental prerequisite, but talent is not enough. Backer exclaimed, "Talent, talent, it all depends on the steadfastness of one's personality."[7] Kielland reflected, "I never say seriously anymore that I doubt I have talent, nor will I take our Lord to task because it is small. I think the size depends greatly on one's character and will."[8] Steadfastness, character and will—these were the essential qualities for success as a professional woman in a male world.

PARALLEL CAREERS, DISTINCTIVE DEVELOPMENT

During the 1870s, when Backer, Kielland and Nørregaard began their art studies, only the most elementary training was available to them in their own country. Consequently, they stayed abroad for ten to fifteen years, in Munich and Paris, to educate themselves and start their

careers. During the years in Germany, they perfected their technical skills, working in a late romantic style. Munich was a gathering place for Norwegian artists in the 1870s, even for women, although the academy was closed to them. Their teachers in Munich were almost all Norwegian artists. At first they followed the paths of their male colleagues somewhat passively.

STUDY IN PARIS

The years of study in Munich provided a good foundation, but it was their long stay in Paris (Backer and Kielland, 1878–89; Nørregaard, 1879–85) that freed these women as artists and made it possible for them to find, each in her own way, an independent and personal means of expression. As we have already seen, they were familiar with impressionism, and it had its effect on them, but they did not consciously seek it out. They equally admired—as did their male colleagues—the salon realists, artists who were somewhere between academicism and the avant-garde. Such artists chose popular subjects and contemporary motifs, freed colors from the conventional browns and grays, took up plein air painting and cultivated the ideal of painting on site. They found these painters in the private art schools, for women were not allowed to study in the École des beaux-arts. The new ideas were put into practice during stays in Brittany and Normandy, provinces which were full of foreign artists. Asta Nørregaard's *Farm Woman from Normandy* (1889) exemplifies the absorption and application of this new knowledge.

The artist who exerted the greatest influence on these women was Jules Bastien-Lepage, who was much in fashion among Nordic artists' circles in Paris during the early 1880s. Many artists imitated his moderate realism, clear, silver-tinged colors and dense brushstrokes. Backer and Nørregaard studied with Bastien-Lepage during their first years in Paris. The paintings of Pierre Puvis de Chavannes also signaled a significant trend. His simplified, strict form and decorative aesthetic had an influence on Nordic painting, particularly during the 1890s. But even as early as the 1880s, his influence was apparent in Kitty Kielland's first atmospheric landscapes.[9]

In spite of numerous obstacles, particularly exclusion from the best art schools, the life of a woman art student in Paris must have seemed emancipated compared to the restricted bourgeois life back home in Norway. Social conventions were freer in Paris and female role models were much more evident. The city was full of women painters from Europe and the United States with whom to share experiences and join forces. Women such as Rosa Bonheur had established careers that were drawing attention. A powerful organization for women artists, the Union des femmes peintres, sculpteurs, graveurs et décorateurs was founded in 1881 and held yearly exhibitions. Foreign women artists were undoubtedly familiar with it and probably had little trouble identifying with its primary goals.[10]

The works the three women artists produced during their Paris years are marked by experimentation. Backer painted primarily interiors. Nørregaard was more versatile, as her *In the Studio* testifies. Kielland painted interiors

and landscapes. All three were responsive to the demands of realism in paintings of contemporary life. Their focus was on bourgeois femininity and its rituals, the home and its inhabitants. These paintings describe a social role for women by depicting places for female social intercourse in which women are absorbed by "work"—reading, writing, sewing and playing music.[11] These were also the subjects and themes of avant-garde artists working in Paris, such as Berthe Morisot and Mary Cassatt. Because of them and feminine impressionism, the private sphere became a component of modernism. Backer, Kielland and Nørregaard experimented cautiously, however. They did not step into modernism in the way the women impressionists did. But for the women impressionists as well, the world was divided into male and female, and the women artists had to find their place.

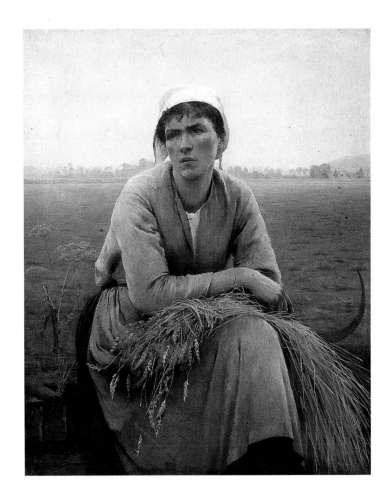

MATURE WORKS
OF THE 1880S AND 1890S

For all three of the artists, the decade of the 1880s was a time to try out various forms and motifs. New skills were put to use. Some were rejected, others took hold and became specialties. The first half of the decade marked the conclusion of their studies and the beginning of three promising careers.

Kitty Kielland. Of the three artists, Kitty Kielland most consistently explored one genre—the landscape.[12] As we have seen, however, even she made little detours by painting interiors during the Paris period. In these works she

ASTA NØRREGAARD
Farm Woman from Normandy (1889)
Oil on canvas, 41 x 33 ½ inches
The National Gallery, Oslo, Norway
Photo: O. Væring, Oslo

29

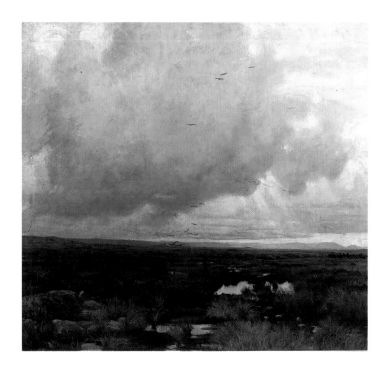

KITTY KIELLAND
Peat Bog (1880)
Oil on canvas, 47 ¼ x 52 ½ inches
Private collection
Photo: O. Væring, Oslo

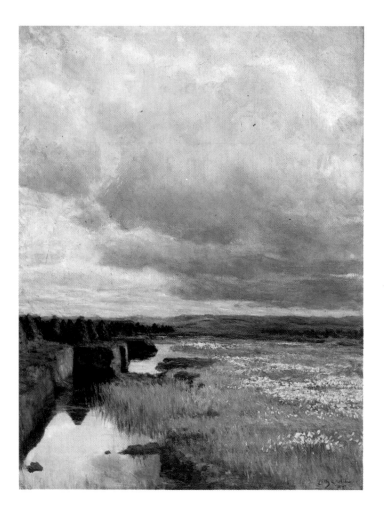

KITTY KIELLAND
Peat Bog (1895)
Oil on canvas, 42 x 32 ¼ inches
Rogaland Art Museum, Stavanger, Norway
Photo: Rogaland Art Museum, Stavanger

stayed with typical female motifs, while in the landscape paintings she sought out motifs that definitively broke with the feminine norm. Of the approximately sixty women painters in Norway during this period, only a very few chose the landscape as their genre, although landscape was the dominant choice of their male colleagues. To set off into nature with an easel and painting accoutrements was too bold for other ladies, but not for Kitty Kielland. And it was not the gentle landscapes that she sought out. Her hometown of Stavanger on the southwest coast was near the extraordinary, windswept region of Jæren, to which she would return throughout her life. The paintings from this region started out as small, detailed, realistic views of nature, utterly lacking in sentimentality. Gradually she expanded the perspective and format to depict nature on a grand scale with vast, dramatic skies—whether looking inland toward the hills or out toward the sea. The heath-covered marshlands became her specialty. Faithful observation of the close-at-hand in nature and wide vistas that give a sense of the whole characterize both her Jæren landscapes and her landscapes from other regions. As early as the 1880s she expanded her repertoire with landscapes from the areas surrounding Paris and from Brittany, as well as eastern Norway and the mountainous regions.

There is a logical, predictable development to Kitty Kielland's landscape paintings, which is not to say that she does not grow as a painter. On the contrary, she was at the vanguard in absorbing new trends. Her early atmospheric landscapes were of greatest importance, with avant-garde qualities that follow Puvis de Cha-

KITTY KIELLAND
After Sundown (1885)
Oil on canvas, 31 ½ x 45 ¼ inches
Rogaland Art Museum, Stavanger, Norway
Photo: Dag Myrestrand

vannes. Her *After Sundown* (1885) and *By the Tarn* (1886, cat. 10) present a close view of nature—the shiny, reflective surface of the water and the muted blue light of the summer night. This evidences a stylization and harmony which contrasts with her earlier paintings, anticipating the symbolism and syntheticism of her work in the 1890s, such as *Sunset, Tyin* (1898, cat. 13). In this decade, realistic and atmospheric landscapes, daylight and evening scenes existed side-by-side in her oeuvre.

Harriet Backer. By the 1870s Harriet Backer had already abandoned her original intention of becoming a portrait painter, but both the portrait and the landscape, as well as the interior, continued to be steady currents in her painting. She developed her own way of paint-

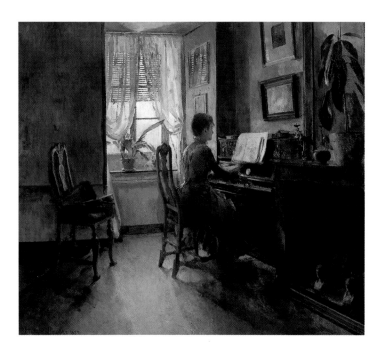

HARRIET BACKER

Chez Moi (1887)

Oil on canvas, 34 ¾ x 39 ½ inches

The National Gallery, Oslo, Norway

Photo: J. Lathion, The National Gallery, Oslo

ing interiors in the early 1880s in Paris, applying the principles of plein air painting and adhering strictly to the requirement that the work be completed on site. She also was influenced by the compositional principles of earlier paintings and by impressionism. Harriet Backer did not paint quickly. On the contrary, she spent a great deal of time on her work, sketching and composing first, before the colors fell into place.

Backer's interiors focus primarily on bourgeois salons, although she also painted the living rooms of farmers. There are always people, most often women, in her rooms—women playing the piano, reading, sewing, taking care of children (*Fourre Tout*, 1881–82, cat. 1; *Music*, 1890, cat. 2; *By Lamplight*, 1890, cat. 3). In spite of her claim that composition, light and color concerned her most, and that the actual subjects were of only superficial importance, her attention to women's work and women's leisure seems intentional. Her paintings owe their strength to these interests. This was the first intense period of the women's movement in Norway, and Backer knew its leaders and sympathized with its goals. In her paintings she depicts women with dignity and respect.

Backer's deeply religious spirit and her engagement with contemporary spiritual currents led her to turn her passion for the interior toward the church in the 1890s. Over the next twenty years, her greatest works were church interiors (*Altar in Tanum Church*, 1891, cat. 4). Selecting beautiful stone churches, as well as stave churches from the Middle Ages, she also was able to cultivate her interest in Norwegian folk culture by depicting their colorful furnish-

ings and decorations from the 17th and 18th centuries. Church interiors framed her portrayal of religious activities, such as christenings, communion and the offering of spiritual guidance. These church interiors were time-consuming projects, even more so than her parlor interiors. She worked on some of them for several years. It was the composition that took time. When the colors were applied, they blossomed more luxuriantly and more beautifully than ever before.

Asta Nørregaard. During the 1880s Asta Nørregaard's work was marked by versatility, as demonstrated by *In the Studio.* She produced elegant paintings in a variety of genres: religious painting, folk painting, the intimate interior and the portrait. Of the three artists, Nørre-

HARRIET BACKER
Baptizing in Tanum Church (1892)
Oil on canvas, 43 x 56 inches
The National Gallery, Oslo, Norway
Photo: J. Lathion, The National Gallery, Oslo

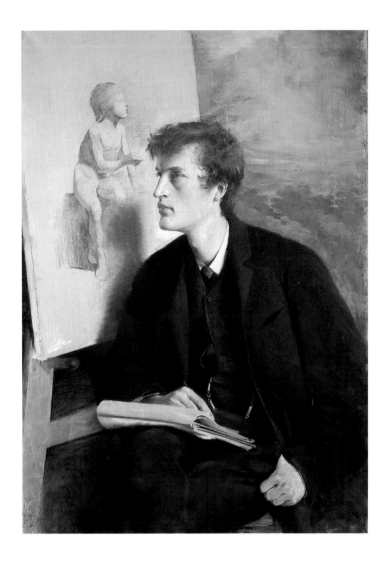

Asta Nørregaard
Portrait of Edvard Munch (1885)
Pastel, 50 x 31 ½ inches
The Munch Museum, Oslo, Norway
Photo: The Munch Museum, Oslo

gaard was the most conventional. She had a great capacity for adapting herself to the "correct" French trends. She studied with Léon Bonnat in Paris, and his advice and example were of great importance. Bonnat emphasized drawing rather than color, instructing her to let nature be the teacher. Many Nordic artists thought Bonnat could be rather linear and dry, but he suited Nørregaard well. He was a successful portrait painter of the upper classes, and in this regard, too, was a model for Nørregaard.

In spite of her distance from the avant-garde, Asta Nørregaard painted the first portrait of one of modernism's leading exponents in Norway, Edvard Munch (cat. 17). While it may seem surprising that the young, radical Munch took the time to sit for the already established Nørregaard, who by 1885 was regarded as a conservative artist, it is also a reminder that in the small and emerging art world of Norway people took advantage of whatever opportunities presented themselves.[13] Nørregaard and Munch probably met in Kristiania (as Oslo was called until 1925) during the fall of 1885, after Nørregaard had returned home from Paris for good.[14] It is conceivable that Munch took lessons from her; we know that Nørregaard had students and that she established her own art school for a short time at the end of the 1880s. She was familiar with the new trends from Paris, and was technically gifted. In addition, she had skills that young artists would naturally find attractive. In this portrait Nørregaard drew a handsome, dreamy and visionary young artist, his eyes gazing into the distance. He is depicted as a student, with a figure study on the easel and a sketchpad in his lap.[15] The painting may

have been made in the same room as *Music Interior* (cat. 18), for the tapestry-like backdrop is the same. The portrait, one of Nørregaard's first pastels, demonstrates that she had mastered the technique completely. She must have learned the technique in Paris, where pastels had come into fashion about 1850 and the Société des pastellistes, founded in 1870, held annual exhibitions.

By the early 1880s Nørregaard had already produced her perfect society portraits, such as *Maggie Plahte* (1881, cat. 15). Not until her stay in Rome in the winter of 1889–90 did her career reach a turning point, dramatically expressed in the self-portrait that she painted during this period. Elegant and fashionably dressed like the upper-class women she painted, and with a face so photo-realistic that it makes one look twice, she expresses resignation, loneliness, perhaps a slightly ironic sense of self. Neither the bags under her eyes nor the tight pull around her mouth have been omitted. From then on Nørregaard painted almost nothing but portraits, no doubt partly for the financial security this specialty afforded and the opportunity to gain a certain social status.

Nørregaard threw herself into her new role, enjoying her best period as a portrait painter until 1905. Kristiania's upper classes were her clientele. Her success was due to her talent for capturing the likeness of her sitter. She never used photographs, as one might have suspected. She was skilled at depicting individual characteristics, idealizing her subject with moderation, and also was talented at rendering fashionable attire and costly fabrics. The figure dominates the picture surface; a single piece of furniture or

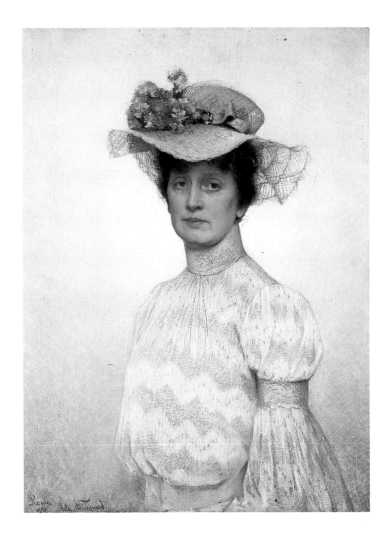

ASTA NØRREGAARD
Self Portrait (1890)
Oil on canvas, 32 x 24 inches
Oslo City Museum, Oslo, Norway
Photo: Oslo City Museum, Oslo

ASTA NØRREGAARD
Portrait of Elisabeth Fearnley, (1892)
Pastel, 80 x 45 ¼ inches
Private collection
Photo: O. Væring, Oslo

an object suggests the milieu or context. The background often has the feeling of a stage set, with patterned wallpaper or foliage.

Pastel became Nørregaard's specialty. Rejecting the impressionists' free chalk strokes applied next to each other, she used canvas instead of paper and the old-fashioned technique in which the colors are blended to create soft transitions. Between 1889 and 1905 she drew sixty pastel portraits of women and children (the portrait of Munch is one of only two exceptions), many of them astonishingly large. The softness of the pastel chalk suited a feminine and childlike nature. She reserved oils for her somber portraits of prominent businessmen and scientists.

REALISM, NATIONALISM AND NEW TRENDS AT CENTURY'S END

The connections among the works of the three artists, which were strong during their years in Paris, grew more tenuous over time. All three returned home to Norway, where each was affected in different ways by the new ideas in the forefront of the Norwegian art debate. Even before 1890 each had developed a specialty: Kielland, the atmospheric landscape; Backer, the church interior; and Nørregaard, the society portrait. How can we view their art at the century's end in light of the old and the new?

During the 1880s Norwegian artists were affected strongly by realism, and this movement helped to liberate all three women as artists. All three participated in the effort to create a national art in Norway—Backer and

Kielland most directly. Kielland was one of the organizers of the Norwegian pavilion of the World's Fair in Paris in 1889, where Norwegian art was displayed and widely noticed. She reflected,

"I was quickly and happily convinced that there was something fresh and intrepid, something bold in the colors and conception, which was personally seen and felt, and which made our section into a uniquely Norwegian exhibition, in contrast to those of all the other countries. It may be that our exhibition lacked the skill and innate elegance of the old cultural nations (where would we have gotten them from?), but it did possess a national character.

Where do the painters want to go in terms of art?

Well, those who are ambitious will attempt to look at our nature and our life through Norwegian eyes, with a new, fresh view, torn away from foreign influences."[16]

The new trends of the 1890s—symbolism, syntheticism, spiritualism—were known in Norway and took many forms, but primarily they coalesced in an emotional, romantic seeking. This trend has been labeled the "new romanticism" in Norway. The original decorative art created in Norway at this time testifies to the renewal of Norwegian art stemming from the confluence of European trends and Norwegian folk art. Fueled by nationalism and tied to tradition, the art of the 1890s could hardly be considered a drastic break with that of the previous decade.[17]

Backer, Kielland and Nørregaard were inspired in various ways by these new trends, but they integrated them into the older values that already characterized their art in form and in content. Kitty Kielland took the initiative with her atmospheric landscapes. She looked for motifs in Norwegian nature—Jæren and the mountains—rejuvenating the form of her art with a certain stylization and synthesis, while not discounting the direct observation of nature. Her works from this period display a deeply romantic mood, bordering on mysticism. Harriet Backer produced an original decorative aesthetic by synthesizing her interest in church interiors with her interest in the folk art used in their furnishings. Her colors became increasingly free, moving toward abstraction in spite of the solid drawing that serves as the base of her compositions. Asta Nørregaard did not intend to create a national art, but the genre she chose—the society portrait—is an integral element of Norwegian art of the 1890s nonetheless. More in tune with an international interest in fashionable, upper-class portraits based in realism but tinged with decadence, in Norway she was an artist working against the mainstream and her efforts often were denigrated. Nevertheless, she stands as a Norwegian counterpart to James McNeill Whistler, John Singer Sargent and Giovanni Boldini.

Decorative aesthetics, symbolism and decadence aside, the three artists have their deepest roots in realism and its demand for authenticity and truth. For them, realism—Kitty Kielland's nature observations, Harriet Backer's solid drawing and composition and Asta Nørregaard's almost photographically realistic figure drawings—was the foundation into which new impulses were integrated.

How was it possible for the three women to establish careers and achieve success in a strongly male society? Several prerequisites have already been mentioned: economic changes that opened new opportunities to women; the women's rights movement, which offered support and legitimacy to women's professional lives; and young, radical art institutions. Still, for a women, a successful career required struggle, a certain shrewdness, the ability to exploit opportunities and an equal amount of courage to break with the norm.

Career consciousness is an important key phrase. But at bottom was art itself and its attractions. Harriet Backer expressed this pull most keenly during a period when she felt she stood at a crossroads and had to choose between an artistic career and fulfilling the role expected of the unmarried daughter still living at home: "If I didn't have such a *passionate urge* (my emphasis), then I would have despaired long ago and given it all up to live contentedly in my happy home with all of you whom I love so deeply."[18] Renunciation was possible only in the face of an all-consuming love for art.

Commitment to art required financial sacrifice as well. In spite of their artistic success, Backer and Nørregaard never achieved financial independence and were always poor. Kitty Kielland was financially independent, but scarcely rich. Very few Norwegian artists became rich.

While sustaining a commitment to an artistic career was difficult, friendship made it less so. The three artists knew each other and followed each other closely throughout their lives. The support they offered one another certainly contributed to the likelihood of their success.

Harriet Backer and Asta Nørregaard went to art school together in Kristiania during the 1870s and were regarded as the best students in their class. Later they studied together in Munich with the goal of becoming portrait painters. They also attended the same art school in Paris. While in Munich in 1875, they got to know Kitty Kielland. Backer and Kielland remained close friends for the rest of their lives, lending each other support at a decisive phase in the establishment of their professional careers following their studies. They lived together for more than ten years in Paris, continuing to do so for a time after their return to Kristiania. Living together had practical, emotional but also professional significance for them. They could correct, criticize and encourage each other as equals. Together they also stood more strongly when confronting the world. It is reasonable to assume that without this arrangement the careers of both artists would have been not only different but impoverished.

From about 1900, Backer, Kielland and Nørregaard lived in the same house. Kielland suffered from nervous diseases from around 1905, and died in 1914. Backer and Nørregaard died in 1932 and 1933, respectively. Each had her own little studio apartment, but they shared

the servants. Backer and Nørregaard had been friends and colleagues ever since they were young, but in their later years their relationship does not appear to have been particularly warm. One of Backer's students expressed it this way: Asta Nørregaard is a *lady*, she surrounds herself with elegant people; Harriet Backer is a *painter*, she surrounds herself with artists. Nørregaard lived a lonely life and was not accepted in the company of successful artists. She was an outsider, both artistically and socially; her allegiances were to the upper class. Harriet Backer, on the other hand, enjoyed a high status among both older and younger artists. For many years she ran a highly respected art school. When she turned eighty, artists formed a torchlight procession to her home, an honor rarely accorded women.

In Norway, as elsewhere in the West at this time, it was common for unmarried women to join forces in pairs and groups.[19] Such relationships met both practical and emotional needs. Women artists traveled abroad together, often lived together and supported each other in dealing with the public exposure involved with being an artist. These private female networks have been characterized as "safety nets,"[20] an appropriate term since they also functioned as private retreats. They inspired an adherence to private, traditional female values and a resistance to change and integration. The Association of Women Painters, founded in 1907, promoted these values. Nørregaard was a member, but Backer and Kielland were not. They broke away from female networks, seeking out and joining the company of men. They were virtually the only women who were part of the trend-setting Norwegian artistic milieu. Accepted by the leading male artists, they participated in contemporary debate and intellectual life as equals. They counted, both artistically and socially.

The Artist and the Unmarried Woman

All three women were involved in different ways in the artists' and women's organizations of the day. Art as a profession was important to all of them, and they felt obligated to participate. Kitty Kielland established a scholarship for the purchase of Norwegian art for the National Gallery. Asta Nørregaard established a rest and recreation foundation for women visual artists. The greatest contribution to the art profession was made by Harriet Backer, however. She was a founding member of art organizations and a member of many juries. She also served on the purchasing committee for the National Gallery. She assumed a kind of male role by entering into the political aspects of promoting art. Apparently she did so quite deliberately to further the interests of women. "By concentrating like a man, I serve the best interests of women," she said.[21]

Concentration at that time was considered a male talent, just as hard work was. And work is a key element in the art and activity of Harriet Backer. She was constantly working, slowly and meticulously. Her work took all of her attention and gave her everything. In her later years she confessed that she had never experienced anything personal. By "personal"

she must have meant marriage and motherhood, for, with strong ties to her sisters and their families and many close friends, she was far from being an isolated loner. She chose to adopt a male professional guise, but felt that, by doing so, she served women best. By virtue of her skill and her work she not only paved the way for women in the art institutions but also became a role model for the women artists of several successive generations.

In choosing the path of a professional artist, Harriet Backer chose the most obvious solution to the special circumstance of the unmarried woman. Kitty Kielland was equally concerned with the emotionally insecure situation in which unmarried women lived. Their dilemma is reflected in many of the discussions about literature and art in which Backer and Kielland participated during the 1880s. Kielland carried the discussion further by getting involved in the public debate regarding these issues, both among the conservative churchmen and with the Norwegian Women's Rights Association, which she helped to found in 1884.[22]

Independence, professionalism and femininity were focal points in this public debate, and Kielland believed that these qualities ought not to be mutually exclusive. Women should not be denied participation in public life, and they should have the right to earn their own living. The radical aspect of her views was that she felt that a profession could be combined with marriage. She disagreed with the church, which claimed that women's special talents ought to be restricted to the female sphere of life—the home—and that it was the woman's responsibility to make life pleasant for her husband and children. The church further advised that unmarried women should assume a service role, extending charity to others. This view that women must remain amateurs, never professionals, was strongly opposed by Kielland as an unmarried woman and professional artist: "As a rule, artistic talent is given some leeway, albeit somewhat limited, which has often astonished me. I wonder whether this could be because it is regarded more as an object of luxury and taken less seriously? Is it even a guarantee that one does not wish to trespass on forbidden territory? Because surely it is not possible that it should be a more direct gift from God than practical talents?"[23] Here Kielland focused directly on the distinctive difficulties faced by a woman artist. The prevalent idea was that women's art was strongly tied to the private sphere and the aesthetics of the home, and that it was produced primarily by unmarried women—the professional woman artist constantly had to fight against the notion that, as an artist, she was an amateur.

Kitty Kielland courageously expressed the loneliness of the unmarried woman and her loss in being unable to fulfill her emotions in relation to the opposite sex, her longing for a family and children. She disputed with the women's movement's own editor, who warned against idealizing marriage in comparison with the importance and happiness of being independent and self-supporting. Kielland formulated a utopia in which women should be independent, professional and have a normal love and family life. Her original, well-developed view of femininity helped her out of the dilem-

ma inherent in promoting a public role for women while also preserving traditional female values. Kielland maintained that femininity is something that exists in a person, not in a position: "Femininity is the inner force that causes us to come together and protect that which is our natural difference from men." As a result, "the more independent one is, the more feminine one becomes."[24]

FROM AMATEUR TO PROFESSIONAL

The career histories that lie behind the rich, diverse art created by Harriet Backer, Kitty Kielland and Asta Nørregaard are like variations on a theme. The three artists achieved a high level of professionalism. Their background was in an amateur culture of bourgeois homes, which encouraged aesthetic activities for the enjoyment of the husband and family. While they managed to break away and become professional artists, they retained some aspects of this amateur culture, which encouraged women to use their free time to avoid indolence, which was a vice, and to express themselves artistically and individually. In their paintings, these artists reveal their version of bourgeois femininity—their own social role as daughter, sister, mother and family member in a domestic setting.

While the backgrounds, education and status of Backer, Kielland and Nørregaard were not unlike those of other women artists of the period, Backer and Kielland, in particular, separated themselves from institutions for women that supported amateur values. Asserting the principle of equality, they formed institutional connections with male artists that promoted the then prevalent social attitudes toward professional work. Men were professionals and women could learn from them. Kielland and Backer broke with notions of how women could achieve professionalism, and Asta Nørregaard did so as well in her own stubborn way. Even though they were marked by their common backgrounds in the culture of the amateur artist and by a conscious and carefully considered attitude toward their own roles as women artists, these artists helped to redefine the role of "the woman artist" in late 19th-century Norwegian society.

NOTES

1 Else Christie Kielland, *Harriet Backer* (Oslo: Asche-houg, 1958), 106.

2 See Barbro Werkmäster, "Bild – självbild – bild själv" [Image—self-image—the image itself], *Konsthistorisk tidskrift* [Journal of art history] 60, no. 2 (1991–92): 88.

3 The most important references are Anne Wichstrøm, "Blant likemenn: Søkelys på Harriet Backer og Kitty L. Kiellands karrierer" [Among equals: spotlight on the careers of Harriet Backer and Kitty L. Kielland], in *Den skjulte tradisjon* [The hidden tradition] (Bergen, 1982): 172-191; Anne Wichstrøm, *Kvinner ved staffeliet* [Women at the easel] (Oslo: Universitetsforlaget, 1983); Marit L. Lange, "Harriet Backer och Kitty Kielland i Paris på 1880-tallet" [Harriet Backer and Kitty Kielland in Paris in the 1880s], in *De drogo til Paris. Nordiske konstnärinnor på 1880-tallet* [They went to Paris: Nordic women artists in the 1880s], ed. Louise Robbert (Stockholm: Liljevalchs, 1989), 113-147; Anne Wichstrøm, "Asta Nørregaard," in ibid., 149–156.

4 Norwegian artists of this generation were introduced to an American audience in the exhibition *Northern Light: Realism and Symbolism in Scandinavian Painting, 1880–1910* which traveled to New York, Washington, Minneapolis in 1982. Catalogue ed. Kirk Varnedoe (New York: Brooklyn Museum, 1982).

5 Wichstrøm, *Kvinner ved staffeliet* gives an overview of Norwegian women painters before 1900, the context in which they worked and their careers.

6 *De drogo til Paris*, ed. Robbert, presents a good over-view of Nordic women artists of the 19th century.

7 Kielland, *Harriet Backer*, 210.

8 Letter from Kielland to Eilif Peterssen 12 March 1877, Oslo University Library, coll. 209.

9 Marit I. Lange, "Fra den hellige lund til Fleskum" [From the sacred grove to Fleskum], *Kunst og Kultur* 60, no. 2 (1977): 69–92.

10 Tamar Garb, *Sisters of the Brush: Women's Artistic Culture in Late Nineteenth-Century Paris* (New Haven: Yale University Press, 1994).

11 See Anne Higonnet, *Berthe Morisot's Images of Women* (Cambridge, Mass.: Harvard University Press, 1992); Griselda Pollock, "Modernity and the Spaces of Femininity," in *Vision and Difference* (London: Rout-ledge, 1988), 50–90.

12 Lange, "Fra den hellige lund til Fleskum."

13 Anne Wichstrøm, "Asta Nørregaard og den unge Munch" [Asta Nørregaard and the young Munch], *Kunst og Kultur* 65, no. 2 (1982): 66–77. Nils Messel demonstrates that Edvard Munch was less of an out-sider in the Norweigan art milieu than is ordinarily assumed. "Edvard Munch and His Critics," *Kunst og Kultur* 77, no. 4 (1994): 213–227.

14 Both Nørregaard and Munch were in Paris during the spring of 1885, but Munch's stay was so brief that there would not have been enough time to produce the por-trait. Wichstrøm, "Asta Nørregaard og den unge Munch," 72–77.

15 See also Alessandra Comini, "Nordic Luminism and the Scandinavian Recasting of Impressionism," in *World Impressionism: The International Movement, 1860–1920*, ed. Norma Broude (New York: Harry N. Abrams, 1990), note 35.

16 "Litt om norsk kunst" [A Little about Norwegian art], *Samtiden* I (1890): 224.

17 Mange Malmanger "Betryggende modernitet" [Reassuring modernism], in *Tradisjon og fornyelse: Norge rundt århundreskiftet* [Tradition and renewal: Norway around the turn of the century] (Oslo: The National Gallery, 1994), 27–47.

18 Kielland, *Harriet Backer*, 44–45.

19 See Carol Smith-Rosenberg, "The Female Worlds of Love and Ritual: Relations between Women in Nineteenth-Century America," *Signs* I, no. I (1975): 1–29.

20 Barbro Werkmäster, "Akademikamrater" [Academy colleagues], in *Anna Nordlander och hennes samtid* [Anna Nordlander and her contemporaries], ed. Barbro Werkmäster (Skellefteå: Museum Anna Nordlander, 1993), 71–91.

21 Kielland, *Harriet Backer*, 308.

22 Wichstrøm, "Blant likemenn," 188–191.

23 Kitty Kielland, *Kvindespørgsmaalet* [The woman question] (Kristiania, 1886), 19.

24 Kielland, *Kvindespørgsmaalet*, 12.

Harriet Backer

1845–1932

1 HARRIET BACKER

Fourre-tout (1881–82)

Oil on canvas, 28 ¾ x 36 ½ inches

Private collection

Photo: Jamie Parslow, Oslo

2 HARRIET BACKER
Music, Interior from Kristiania (1890)
Oil on canvas, 15 x 18 inches
The National Gallery, Oslo, Norway
Photo: J. Lathion, The National Gallery, Oslo

3 HARRIET BACKER

By Lamplight (1890)

Oil on canvas, mounted on wooden plate, 14 x 17 ¼ inches

The National Gallery, Oslo, Norway

Photo: J. Lathion, The National Gallery, Oslo

4 HARRIET BACKER

The Altar in Tanum Church (1891)

Oil on canvas, 26 ½ x 21 ¼ inches

Private collection

Photo: O. Væring, Oslo

5 HARRIET BACKER

The Living Room at Kolbotn (1896)

Oil on canvas, 24 ¼ x 33 inches

The National Gallery, Oslo, Norway

Photo: J. Lathion, The National Gallery, Oslo

6 HARRIET BACKER

Einundfjell (1897)

Oil on canvas, 38 ½ x 51 ½ inches

Rasmus Meyers Collection, Bergen, Norway

Photo: Geir S. Johannessen, Bergen

7 HARRIET BACKER

My Studio (1918)

Oil on canvas, 30 x 36 ½ inches

Bergen Billedgalleri, Bergen, Norway

Photo: Geir S. Johannessen, Bergen

Kitty Kielland

1843–1914

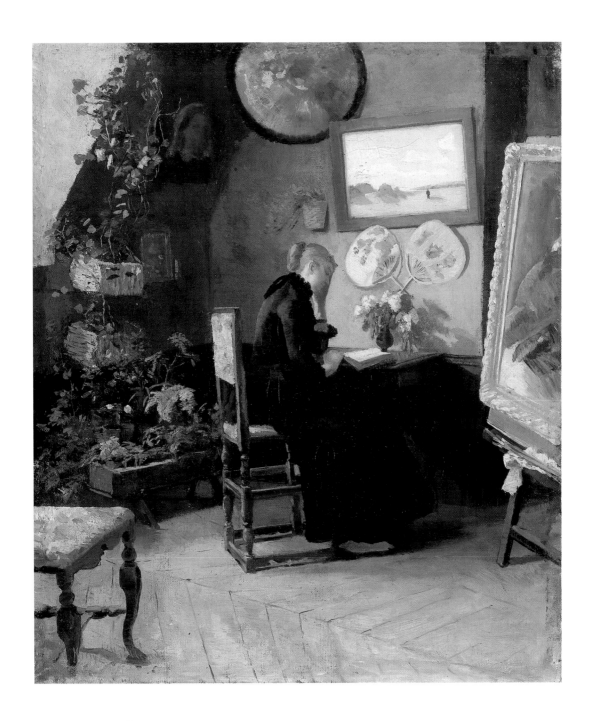

8 Kitty Kielland

Studio Interior, Paris (1883)

Oil on canvas, 16 ¾ x 14 ½ inches

Lillehammer Art Museum, Lillehammer, Norway

Photo: Lillehammer Art Museum, Lillehammer

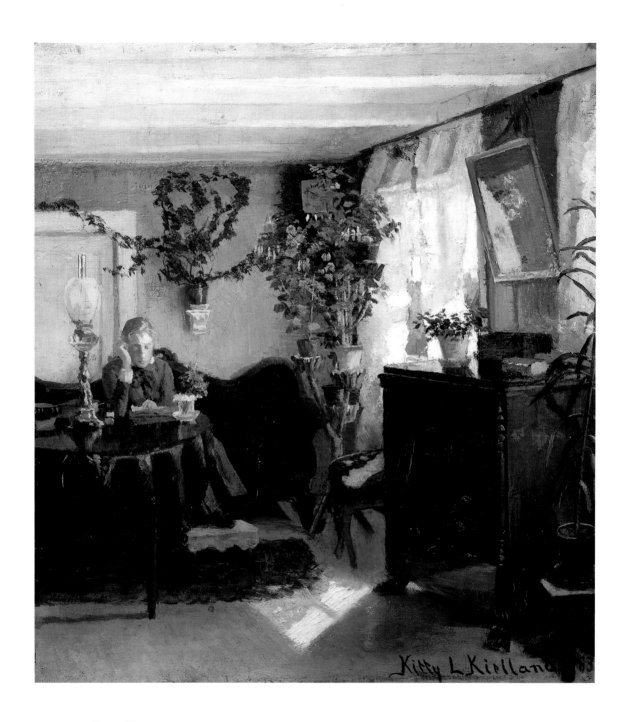

9 KITTY KIELLAND

Blue Interior with Sitting Woman (1883)

Oil on board, 16 x 12 ½ inches

Private collection

Photo: O. Væring, Oslo

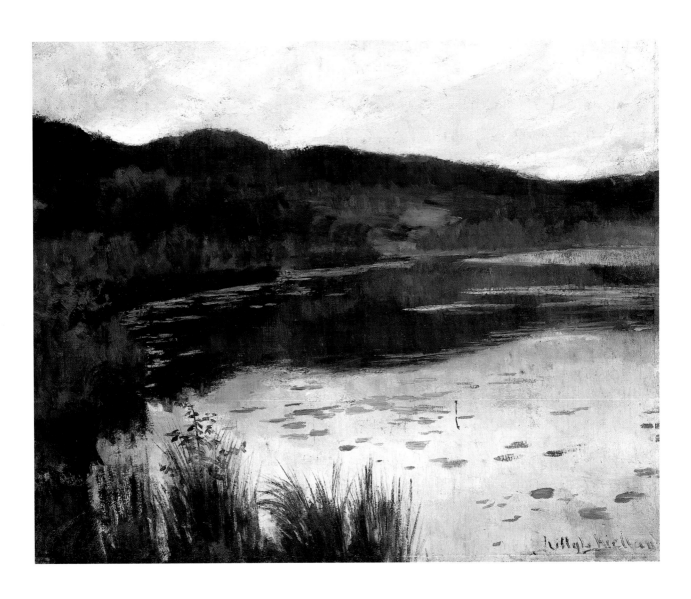

10 KITTY KIELLAND

By the Tarn (Study) (1886)

Oil on paper, mounted on canvas, 15 x 18 ¼ inches

The National Gallery, Oslo, Norway

Photo: J. Lathion, The National Gallery, Oslo

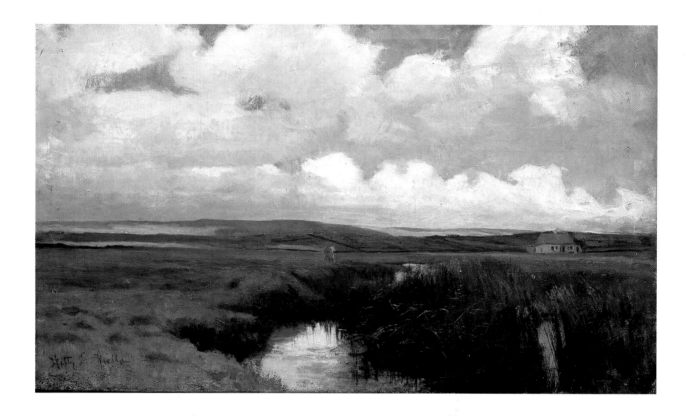

11 KITTY KIELLAND

Jærgård

Oil on canvas, 12 ½ x 21 ½ inches

Private collection

Photo: Øistein Thorvaldsen, Oslo

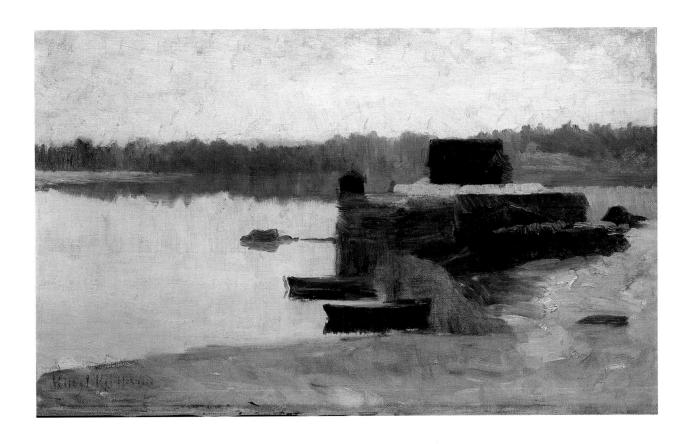

12 KITTY KIELLAND
 Summer Evening (1890)
 Oil on canvas, 11 ½ x 19 inches
 Private collection
 Photo: J. Lathion, The National Gallery, Oslo

13 KITTY KIELLAND
 Sunset, Tyin (1898)
 Oil on canvas, 24 x 43 ¾ inches
 Private collection
 Photo: Rune Aakvik, Oslo

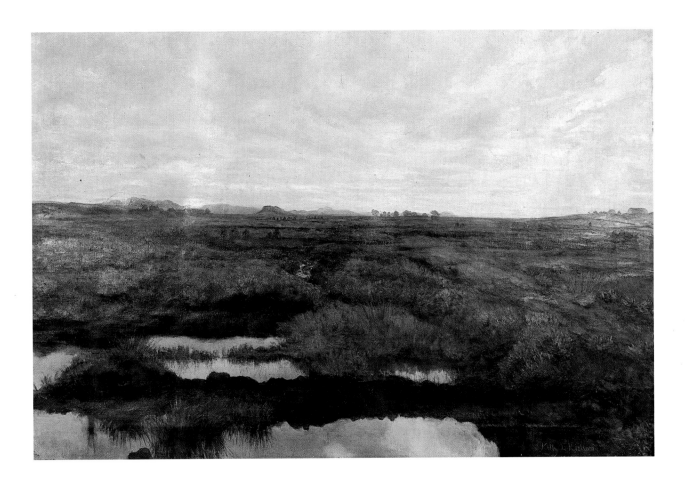

14 KITTY KIELLAND

Peat Bog – Jæren (1901)

Oil on canvas, 34 x 51 ¼ inches

Stavanger Museum, Stavanger, Norway

Photo: Åge Pedersen, Stavanger

Asta Nørregaard

1853–1933

15 ASTA NØRREGAARD
Portrait of Maggie Plahte (1881)
Oil on canvas, 22 ½ x 17 inches
Private collection
Photo: O. Væring, Oslo

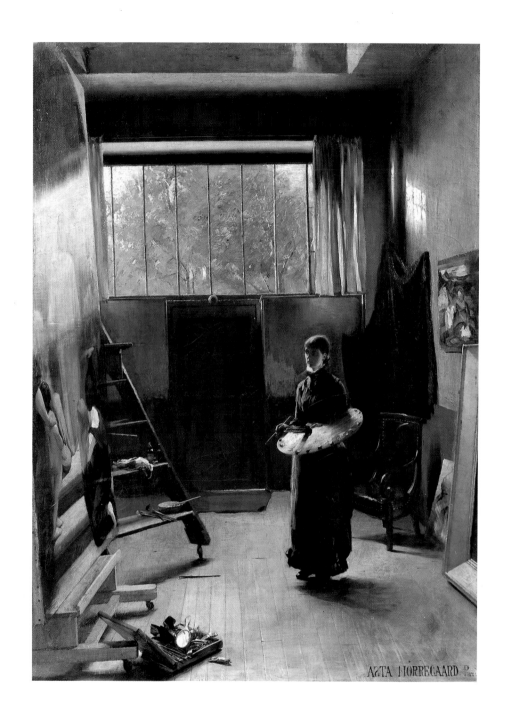

16 ASTA NØRREGAARD

In the Studio (1883)

Oil on canvas, 25 ½ x 19 inches

Private collection

Photo: O. Væring, Oslo

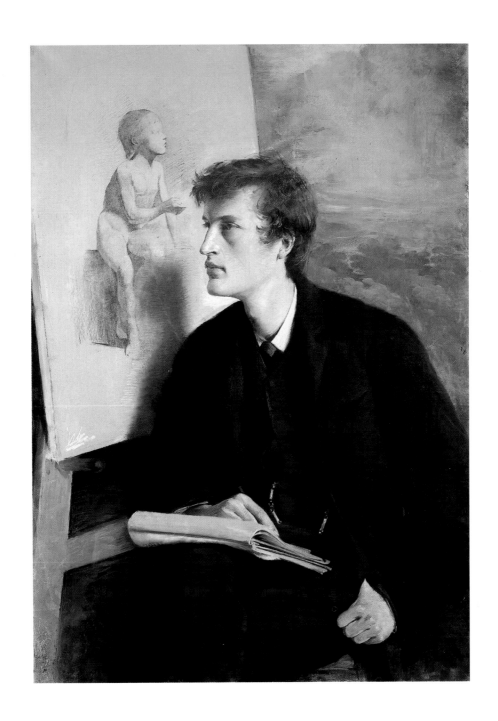

17 ASTA NØRREGAARD
Portrait of Edvard Munch (1885)
Pastel, 50 x 31 ½ inches
The Munch Museum, Oslo, Norway
Photo: The Munch Museum, Oslo

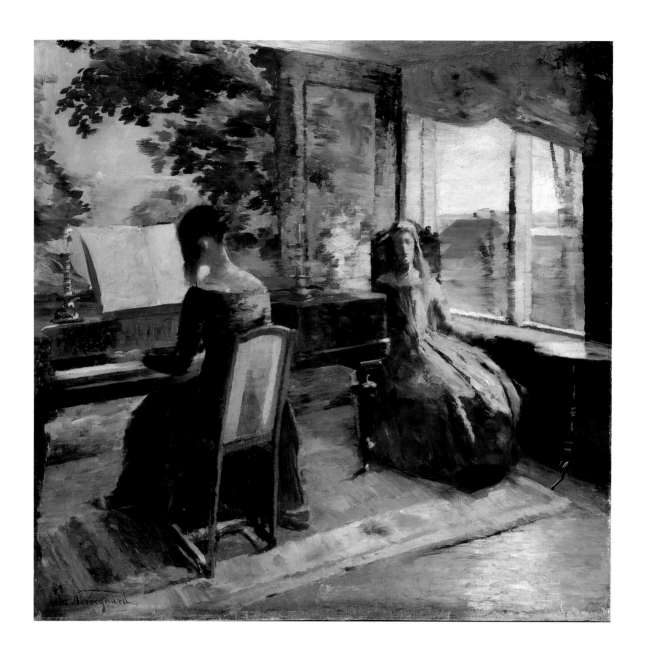

18 ASTA NØRREGAARD

Music Interior (1885 ?)

Oil on canvas, 28 ¾ x 29 ¼ inches

The National Gallery, Oslo, Norway

Photo: J. Lathion, The National Gallery, Oslo

19 Asta Nørregaard

Woman Reading by an Open Window (1889)

Oil on canvas, 19 ¾ x 13 ¾ inches

Private collection

Photo: O. Væring, Oslo

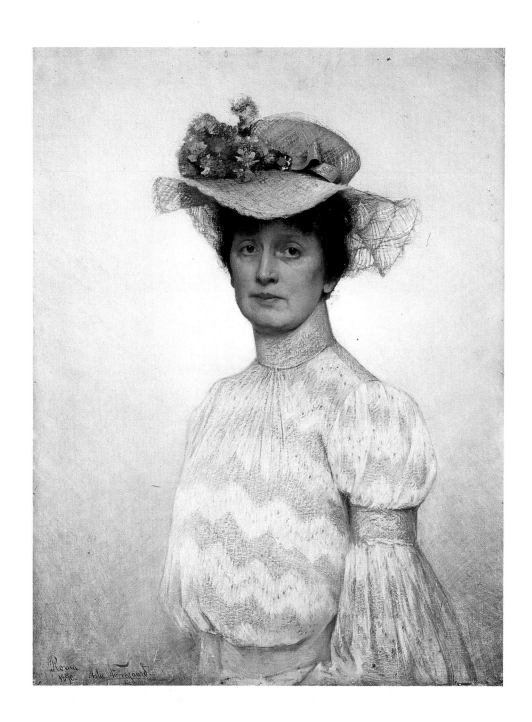

20 ASTA NØRREGAARD

Self Portrait (1890)

Oil on canvas, 32 x 24 inches

Oslo City Museum, Oslo, Norway

Photo: Oslo City Museum, Oslo

Contemporary Figuration: Images of the Mind

TORIL SMIT

INTRODUCTION

The thematic framework of the exhibition involves two developments in art history: realism from the final decades of the last century and contemporary art at the end of our own century. In contrast to historic realism or naturalism, contemporary art is an unfinished chapter in the process of creating itself.

The juxtaposition of this art on either end of a hundred-year time span reveals a far-reaching perspective, which, by its very nature, bridges the time period in between. It links a period that stood on the threshold of modernism with present-day postmodernist art. This encounter is interesting from several perspectives—from the standpoint of the long-standing figurative tradition, the influence of various forms of abstraction, including minimalism and conceptualism, on current figurative art, as well as the position of women in art history when seen through their changing roles as both creators and subjects of art.

Concurrent with the prelude to the women's movement and the struggle by women to gain equal rights with men, women artists have assumed a more prominent role in the art world. In Norway today, after a hundred years of effort, the social, political and economic barriers that women historically had to overcome to establish themselves as professional artists have largely vanished. The number of women artists has increased accordingly; women now represent over fifty percent of the artists in the educational field. Nevertheless, men continue to dominate, especially in the upper reaches of the art world and in prestige accorded. The slogans of the Guerrilla Girls remain relevant in the Norwegian art world, too. In spite of the fact that there is still progress to be made, however, the situation for today's women artists is much more open than that of their predecessors, and women are making vital contributions to the establishment of new artistic positions and movements.

In comparison with the dominant trends in international art centers of the world, the development of figurative art during this century in Norway represents a singular case study. Figuration has held a consistently strong position and changing art styles have maintained a national perspective, even though outside influences have been integrated into or adapted to what can be defined as a Norwegian tradition.

The history of Norwegian art has had its own internal references. There are many explanations for this, but one specific factor is Norway's position on the outskirts of Europe, both geographically and culturally. Located on the periphery of the world's art centers, Norwegian art assumes a provincial status, although this does not necessarily have a negative connotation. As a relatively young independent nation (Norway obtained its constitution in 1814 and its separation from Sweden in 1905), the country has found it necessary to build and maintain its own traditions. Another contributing factor to Norway's distinctive art is its strongly rooted value system. Norwegian values such as equality and democracy have fostered an artistic perspective that emphasizes the function of art, preferably in an accessible and narrative form, as a mediator of human and societal relations.

There has long been a tendency for mainstream directions and international "isms" to arrive in Norway after years of delay. For instance, modernist abstract art had a difficult time penetrating the Norwegian milieu. It was not until the 1960s that abstraction was accepted, following heated debate in the art establishment in the 1950s caused by abstract works by a relatively small group of artists within the young, post-war generation. Norwegian abstract art was based primarily on the post-war École de Paris style, particularly lyrical abstraction and *art informel*. That these types of abstraction were incorporated into the national tradition at all was principally because of their expressed connection with nature as theme and source of inspiration.

Landscape painting constitutes a storyline in Norwegian art dating to Johan Christian Dahl and the rise of national romanticism in the 19th century, and the link between abstract art and nature allowed abstraction to be seen as a continuation of an important art historical heritage.[1]

Norwegian abstract art soon was challenged, however, by a new style of figurative art wielded by a young generation of rebels. Their work, which was inspired by pop art and neo-realism, was experimental and became increasingly critical of society.[2] On the other hand, a neo-romantic and historistic tendency also emerged at this time.[3] Minimalism and conceptual art gained only a small foothold in 1970s Norway, a decade predominantly characterized by figurative pluralism. While political and socially involved art was typical of the times, artists also produced works on more universal themes with symbolic, expressive and existentialist content, often connected to an overall romantic-expressionistic tradition in Norwegian art. Next to these movements, the art scene since the 1950s also shows their rational counterpart along the line of concrete art, hard-edge, op art and later the influences of minimalism.

In general, a strong isolationism marked the 1970s, although this trend was not uniform. Much of the politically radical Norwegian artists' energies, also were expended in the political struggle for legislation supporting the arts. Their efforts were generally successful and, from an international perspective, Norway's enactment of extensive legislation providing state funding for artists as cultural workers is unique in the world.

What some people term the "international exile of painting," from 1965 to 1980, definitely does not apply to Norway. When the new painting and new figuration gained prominence in the international art arena around 1980, this did not signal an abrupt transition for Norwegian art. Nevertheless, a significant change in attitude occurred among the younger artists during the 1980s. They began to demonstrate a new openness toward contemporary international art, which has continued ever since. Their connection with the international art scene has become a natural dialogue fostered by the increasing access to information and exhibitions through the communications media and travel. A number of artists also attend art schools abroad, often as a supplement to their art training at home. This is the case for most of the contemporary artists

shown in this exhibition, who have lived, worked or studied abroad for shorter or longer periods—in Sweden, Holland, France and/or the United States.

While 19th-century artists belonged to an era in which art cast an observant eye on its contemporary surroundings, today's figurative art turns its gaze inward. The return to recognizable imagery in late 20th-century art has a strong psychological, as well as metaphorical or allegorical, component. Many of the contemporary artists in the exhibition use the interiors, landscapes and portraits produced by Harriet Backer, Kitty Kielland and Asta Nørregaard as reference points, suggesting that this new work is part of an extended tradition. And yet, these historical genres are by no means directly transferred to contemporary work, which maintains a free, even iconoclastic, attitude toward art of the past. Ida Lorentzen's interiors, for instance, provide the exhibition's closest link with 19th-century figurative painting. They are distinctly different, however, because of the artist's thorough understanding of modernist abstraction. Along with Kristin Ytreberg, whose sculpture installations resemble rooms or hall-like spaces, Lorentzen both builds upon and recasts the meaning of the domestic interior, a scenic background traditionally associated with women artists. For Marianne Heske, as for her 19th-century predecessor Kitty Kielland, nature is an important theme; yet, here again, it is nature transformed. Through Heske's understanding of conceptual art and use of video images, nature becomes a referent or touchstone, a concept that has been abstracted and distanced from the real thing.

Line Wælgaard, Hege Nyborg and Hanneline Røgeberg also clearly look backward in history, past 19th-century realism to figurative art of the Renaissance and baroque eras. With a critical eye they refocus our attention on the representation of women in art from these periods (Nyborg also looks at other forms of visual and textual documentation), assessing and reformulating a predominantly male tradition on their own, often feminist, terms.

Contemporary art offers a sharp contrast to 19th-century realism with its naturalistic figuration and illusionistic pictorial space. Realism represented the last stage in a four-hundred year history of stylistic experimentation based upon the illusionistic portrayal of reality. In the 20th century modernism rejected this norm, substituting abstract art and the primacy of materials for illusionary figuration. Nevertheless, over the past twenty years, the hegemony of modernist abstraction has been whittled away, along with its prohibition against overtly recognizable imagery.

Conceptually, much of today's postmodern figurative art is characterized by a puncturing of reality and illusion, whether by presenting an image as a dream, fiction or lie, or by offering an image that refers to its own autonomous status as an image. Looking at the work of the artists in the exhibition, it is difficult to imagine their renewed, theoretical interest in figuration without modernism's prior rejection of the past; and yet, it is equally difficult to imagine that their interest in figurative art could be sustained without their own rejection of modernism.

Landscape As Energy— Marianne Heske

At the end of the 19th century, landscape painting was not considered feminine. As Anne Wichstrøm has pointed out, Kitty Kielland was an exception when she, as a woman, chose the landscape as her main genre. Although today this prejudice against female landscape painters no longer exists, the genre is still not widely practiced by women artists.

The traditional viewpoint is that it is man's mission to conquer, challenge and control nature, as well as explore the unknown. Men are still primarily the ones who ski to the North Pole and climb the highest mountains, although women also have begun engaging in such pursuits. The urge to test one's strength against nature is considered a masculine trait. Since the 19th century and the advent of romanticism, it also has been common to view landscape painting as a predominantly male preserve. The landscape becomes a metaphor for the artist/creator and the human mind, or conversely, nature is endowed with qualities by the artist. The myth of the artist-hero which originated in romanticism also bears a male signature. Man alone is seen as having the ability to contact the sacred and sublime, which, by dint of his prodigious talent, he translates and transforms into the highest forms of art. Genius, as we know it, is not associated with women. Since the advent of 19th-century romanticism, therefore, landscape painting has had a trebly masculine significance. In Norway the landscape has also played an important historical role as a symbol of national independence—from the expansive mountain scenery of the national romantic movement of the 19th century to the neo-expressionist paintings of the 1980s.

Marianne Heske's video landscapes and installations from the 1980s and 1990s represent a radical break with this august tradition. Her work adds new dimensions and experiential references to the genre, while offering critical commentary. Her tools are not paintbrushes and oils but modern electronic visual media. She begins by recording mountain landscapes with a video camera and manipulates the images on the spot according to the light, colors and formations of the landscape. Returning to the studio, she edits this material and selects a number of freeze-framed images for photographic reproduction and, later, transference via computer and ink-jet onto silkscreen, metal plate or paper. Working directly with the video image, she manipulates the natural hues on the screen to a point at which they are transformed into clear, synthetic-looking swaths of color. Now highly abstracted, the images seem like mirages of mountains, glaciers and valley slopes, presented through an electronically veiled eye in a science fiction world. In a strange way, they are reminiscent of Dahl's idealized, romantic landscapes of the 19th century, as they might exist within the city-dweller's imagination, resurrected in the highly urbanized, technologically manipulated form of today's society. Heske titled the first of these landscape works *Voyage Pittoresque* (1986), with an ironic nod to today's colorful tourist brochures and postcards—Norway's national cultural heritage as cliché.

The disinterested commentary on the romantic tradition implicit in Heske's video-manipulated vision brings to mind Henrik Ibsen's challenge to "break out of the barrel of the self" (*Peer Gynt*). The naturalistic landscape of the 19th century did exactly that through plein air painting, in which objective observation of nature was emphasized, free of any mysticism. While naturalism turned its eye directly toward the countryside, however, Heske has made use of the video camera's recording eye to remove the subjective dream from her work. Yet this is only one aspect of her creative effort, for in her manipulation and the ambiguity that results, these large-scale natural equivalents become dizzyingly exotic fantasies despite themselves.

The combination of familiarity with and remoteness from the landscape is an integral part of Heske's own experience. She grew up in a little village in a mountain valley of western Norway, but established contact with the international art world early. Captivated by the conceptual and process-oriented art of the 1970s while studying in Paris, London and Maastricht in the Netherlands, she returned to Oslo in 1980, which continues to be her home base.

As an artist Marianne Heske is quite practical and down-to-earth in her use of high-tech media. Heske couples her artistic ideas with objects, people and settings encountered in her daily life, while her tools encompass graphics, photographs, video films and computers. At the very core of her art is the process itself through which the images are created using these different media. Her work is a layered form of communication, which functions sim-

MARIANNE HESKE
From series *Mountains of the Mind* (1988)
Videopainting on canvas, 177 ¼ x 78 ¾ inches
Private collection
Photo: Marianne Heske

MARIANNE HESKE

N.N.

Bronze bust with phrenology faculties (1979)

Collection of artist

Photo: J. Lathion, The National Gallery, Oslo

ultaneously to filter, order, stage and critique her surroundings.

Beginning in the 1970s her photographs, assemblages and video installations demonstrated a clear social commitment. In these works Heske used and reused standardized, manufactured Kewpie-doll heads as sculptural forms, masks or montaged motifs in street-scene photo-dramas. Often the doll heads symbolized conformity, or society's pressure on the individual to fit in and the role-playing that results. She went on to elaborate on this concept by adapting the early 19th-century theories of phrenology to her work. In the pseudo-science of phrenology, the inner character of a person was believed to be related to the skull's outer shape, and could be identified and traced through a network of zones on the skull. Long-rejected by scientists, Heske's work employs phrenology and its "zones of the soul" as a conceptual reference to the multiple aspects of society which influence and monitor our psychic, emotional and physical existence.

Another early and important example of Marianne Heske's appropriation of a ready-made object for conceptual artistic purposes was *Project Gjerdeløa* (1980). To create this installation, Heske shipped an 17th-century wooden shed from her home district of Tafjord, Norway, to the Centre Georges Pompidou in Paris and back once more to its original site. By transferring the object from one very specific place to another, the project demonstrated the way in which context becomes the decisive framework for the definition of art. From non-art to art and back again, the otherwise "vegetative" shed became a mode of com-

munication, giving rise to questions about the meaning of place, time and space.

Project Gjerdeløa was an unusual bellwether in the context of Norwegian art of the early 1980s, for it heralded the beginning of a new, more experimental and international orientation to art-making. The installation had a substantial impact upon the generation slightly younger than Heske, which, by and large, reacted against Norway's socially conscious art of the 1970s, concentrating instead on "art as idea" experimental media, materials and techniques. As installation art gained prominence during the decade of the 1980s, women became increasingly identified with the field. One explanation for this is that women felt freer to explore this new area of art because, unlike painting, it was not "burdened" with a strong tradition of patriarchal dominance.

MARIANNE HESKE
Project Gjerdeløa (1980)
Centre Georges Pompidou, Paris
Photo: Marianne Heske

Marianne Heske's grounding in conceptual art and new media contributes to the reasons why she has been able to project an alternative vision of the Norwegian landscape from *Project Gjerdeløa* (1980) to the present day. In the recent work *Avalanche* (1993) (cat. 21), Heske's doll heads and landscape imagery meet in a new constellation. This time the mountain has changed from a beautiful, static natural wonder to a violent force creating a massive surge of overturned boulders, uprooted trees and tons of deadly ice and snow. The video camera captures the details of the mountain's slide. Its rain of "cosmic spheres" and massive formations are projected in motion, then manipulated and photographically transferred onto sandblasted metal plates. The resulting eight sections are then hung on a steep diagonal from the ceiling and partway along the floor. A cascade of small pieces of "ice"—1001 identical doll heads cast in crystal with an individual shard of color at the center of their frozen skulls—projects beyond the metal plates like scattershot on the floor. Through their inclusion, the natural avalanche is transformed immediately into a symbol of human catastrophe. Heske has given it several meanings. "The avalanche is something that happens when there's too much of something. Everything goes out of control. It starts at the top and takes everything with it. You have psychic avalanches, revolutions, people destroying things. It's in nature, in people, in psychological and political situations. If you keep too much in, you then explode. We are reflections of our environment, whether we like it or not."[4] With its abstracted, still photograph of a huge physical mass in motion and

its multitude of small, frozen heads, *Avalanche* conveys the impression of violent, uncontrollable human, a.k.a. natural, but undesirable forces at work.[5]

An important characteristic of Heske's *Avalanche* is that the experience of the artwork exists beyond the realm of the purely visual. The artists seeks to involve more sensory organs, both real and conceptual, than just the optic nerve. For example, she places the picture plane on a diagonal, so the slide projects into our viewing space and aligns with the doll heads at our feet. In this way the physical presence of the work acts as a destabilizing factor in our visual experience of the slide. A certain confusion arises between our body's proximity to the leaning metal plates and our eye's distance from Heske's photo of the faraway avalanche. She further underlines the physical and material properties of the avalanche through her selection of materials such as crystal and aluminum. In addition she uses the medium of the video, with its thousands of individual pixels which become analogues for natural forces in motion. We vacillate between observing and participating in the work. The installation creates a friction among all of its component parts that can be described in one word—energy, both physical and psychic.

References to a wider sensory range are more explicit in others of Heske's video paintings. Conceptual pairs such as hot/cold, organic/ inorganic, soft/hard may be made concrete, for instance, through a juxtaposition of sheep's wool and metal plates. The work *Tunnel* (1991) incorporates a heat source that radiates warmth, while the surface of the painting remains cold. *Orgone Houses* (1993), built following the design of Wilhelm Reich's controversial orgone box, activates associations with Reich's concept of life energies. Even more important is the work's connection with the concept of the three-phase development of energy as Joseph Beuys defined it: 1. material and chaos; 2. movement as process or work; and 3. thought.

Heske's references draw on a systematic exchange of knowledge and observation from widely diverging spheres, both her own and others'. She assumes a kind of interdisciplinary posture in an exchange in which cultural science, social science and the natural sciences are joined. In contrast to the sciences, it is the privilege of art to be open, ambiguous, unencumbered. In her work Heske crosses from ethnology's interest in the culturally symbolic value of objects to sociology's interest in human relationships—and further on to natural phenomena, technology and communication, as well as art and the human psyche. She might be called a geographer because her process can be compared to map-making, in the broadest definition of the word. Heske's art delineates all the facets which determine the dynamics of existence—the combined network of outer and inner relations which shape our identity.

THE INTERIOR:
A MENTAL SPACE—
KRISTIN YTREBERG AND IDA LORENTZEN

While Marianne Heske's installations deal with human social conditioning through critical analogies to 19th century naturalism, psycholo-

gy and the landscape, Kristin Ytreberg and Ida Lorentzen's art is connected with the traditional subject matter and psychological space of interior scenes from the late 19th and early 20th centuries. Kristin Ytreberg's work, however, operates outside the realm of painting in the three-dimensional space of actual room-size installations. The objects in these installations approximate furniture and fixtures—a bed, a chest, a pillow—but assume the language of poetry. They create a quiet, open place for contemplation, free association and the flight of ideas, like a waking dream. Ytreberg's many years as an architect partially explain her interest in this architectonic language of form; her concern for the characteristics and possibilities of the material reflects the engineer in her. Her works shift between cool, strict geometric construction and fluid, organic sensuality, often incorporating both simultaneously.

"To make much of little" describes her attitude in many ways. Her subjects are trivial bits of domestic life, which she has chosen to recreate from inexpensive, non-art materials, such as zinc and lead. Yet she transforms these materials, not normally connected with the aesthetic, not even within their more prosaic utilitarian fields, into something beautiful, otherworldly and noble—delicate forms whose surfaces reflect the play of the light and, perhaps, the passing of a ghostly presence.

Ytreberg's use of zinc and lead is not completely dissociated, however, from contemporary artistic concerns. In the 1960s minimalist sculptors Carl Andre and Richard Serra used industrially manufactured raw materials such as these with different intentions in mind. Free

from all artistic associations, the artists emphasized the materials' physical characteristics through their radically non-figurative art. Minimalism's redefinition of the concept of sculpture, from an optically illusory object to a physiologically charged sense of space, is a distant yet fundamental precursor of Kristin Ytreberg's work. Her continuing emphasis on situation and place, on examining the sculptural object in relation to its surroundings and the viewer, is important for Ytreberg. Her space is not an artistic "laboratory," however; it is a space in which image and figuration are once again significant.

Ytreberg grew up in a greenhouse, surrounded by garden and landscape architecture, which is another source of her ideas on form, space and materials. Just as the gardener or landscape architect makes an incursion into the plant world and orders it's appearance and meaning, Ytreberg works with the trappings of domesticity—home, hearth and human habitation—and alters them to suit her own vision.

The size and scale of her sculptures is determined by the limitations of her own physique. She likes objects that are simple to create, so that she does not have to send them elsewhere for production. All the work is done by hand. She knits, pleats, folds and braids in the best feminine tradition, using typical domestic handicrafts traditionally situated near the bottom of the artistic hierarchy. She has no expressed political agenda in using these techniques; they are simply part of her aesthetic. Using these homespun techniques she explores the decorative, as well as functional, possibilities inherent in lifeless lead or ordinary zinc. Through

Kristin Ytreberg
Detail from *Saturnus, 6th letter* (1994)
Lead
Collection of artist
Photo: Jamie Parslow, Oslo

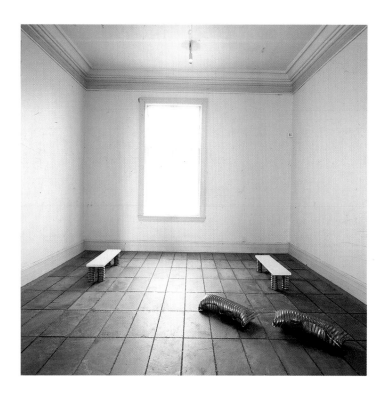

Kristin Ytreberg
Waiting Room (1992)
Installation, travertine, lead and slate
Collection of artist
Photo: Dag Alveng, Oslo

her artistry, she transforms them to reveal unsuspected qualities that elevate their base materiality. A zinc and lead bed, for instance, is created to scale, but its function is taken away. No longer of everyday use, it is a simulation of a quotidian object. The bed, which hangs on an old camp-cot frame, can be viewed as a pure minimalist form or it can prompt associations with a stretcher, perhaps even death. The lead, with its saturated weight and density, prompts thoughts of our bodies as earthbound objects. With the inclusion of such sculptures, the room itself becomes a conceptual space rather than a real living area.

Ytreberg uses her repertory of objects over and over again in different combinations, which keeps their meaning in a constant state of flux. Literally and figuratively, we find ourselves in perceptual gray zones. In the installation *Single Room* (1992), the bed is placed together with a cake pan (cat. 32). In this naked, overly ascetic bedroom, the pan begins to resemble a closed container, filled perhaps with hidden memories of the space. The state of the room conveys both isolation and privilege, a complete void and/or a peaceful chamber for thinking. In this context, the bed is an ambiguous, but somehow terribly ominous, presence. If, however, a metal pillow—a bulblike sack with a gracefully pleated edge—is placed in the room, the surroundings appear more relaxed and one's thoughts shift to organic objects like cocoons or even seaweed pods floating on top of the waves.

In contrast to classic figurative sculpture, Ytreberg's furnishings do not attempt to fool the viewer. Even though a sculptural object may look like a bed, its materiality ultimately

hinders the illusion. Although it may be mere convention that makes it easier for us to believe in illusionistic human figures created out of marble or bronze, Ytreberg's works do not imitate that tradition. Her furniture is not placed on pedestals but willfully coexists with the viewer, which makes it almost impossible for one to be seduced by illusion. Instead the object functions as a simulation, which makes the space around it feel unreal but not illusionary. With Ytreberg's installations, we have definitely entered a psychologized space in which pseudo-fixtures give free rein to our imagination. Situated in this way, the viewer becomes an equal partner with Ytreberg's objects in ever changeable and exchangeable meditative installation spaces.

Ida Lorentzen paints interiors and, as with Ytreberg, they are psychologized interiors which meditate upon inner states rather than external facts. Achieving a visual correlation between the real and the unreal is likewise just as important a matter for her, a fact which is emphasized by the artist's use of different viewpoint and perspective distortions within a single work. Unlike the illusionistic interiors of past art, Lorentzen does not paint habitable rooms; rather, she uses naked walls and bare floors as stage sets which frame carefully composed displays of tables, chairs, stools and mirrors. A doorway and a window usually complete the perfectly sober selection of interior elements.

Lorentzen depicts the objects and environs in her paintings with meticulous care and convincing realism. Nevertheless, one does not perceive the works as realistic representations, but as dream imagery, symbolic expressions of

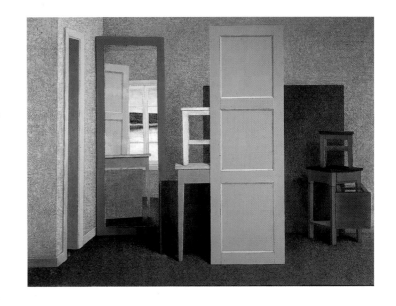

IDA LORENTZEN
Awake or Asleep We See Forwards or Back (1993)
Oil on canvas, 51 ½ x 63 inches
Courtesy of Babcock Galleries, New York
Photo: Bengt Wilson, Oslo

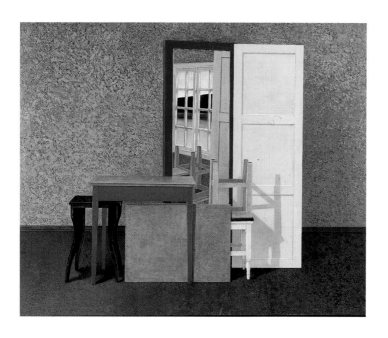

IDA LORENTZEN
Only Love's Pleasures Touched My Heart (1993)
Oil on canvas, 55 x 67 inches
Private collection
Photo: Bengt Wilson, Oslo

an inner I, a soul's identity. This results partly from the fact that her rooms are devoid of people, and that the furniture has been arranged with intentions other than normal use. Equally important, the illusions she creates are false, almost imperceptibly false. Subtle dislocations in the architecture and the spatial relationships undermine the perspective and remove the room from reality. The objects then follow along into an uncertain space.

Lorentzen's paintings hearken back to a tradition which includes artists such as Edward Hopper, who was once her teacher, although she feels more of a spiritual kinship with Jan Vermeer, Vilhelm Hammershøi, Harriet Backer and Giorgio Morandi. The word *silence* often is associated with Lorentzen's painting. If silence can be used as a common denominator to describe the work of Lorentzen and her predecessors, it remains a silence expressed in widely divergent ways. In Vermeer's works the everyday scenes are condensed into soundless moments in which time seems to have stopped. In Backer's paintings, a peaceful atmosphere pervades her interiors. This restfulness emanates not only from the imagery portrayed but from the way in which light effects merge with the paint itself. It is almost as if the light, alone, were creating the interior.

Lorentzen's silence is entirely different, more psychically charged. The tension beneath the surface silence has some resonance with Hopper, but unlike the feeling of isolation and desolation evoked by his small-town vistas, Lorentzen's interiors hide individual conflicts and relationships. As in Backer's painting, the formal expression is inextricably bound to the content of the

image. Of course, it is possible to claim that form and content are always inseparable entities. In some instances, such as abstract painting, form seems to be the foundation of content to a greater extent. From a historical perspective, Harriet Backer stood on the threshold of modernism, approaching the problems of non-figuration from a painterly, coloristic perspective. Ida Lorentzen, at the other end of modernism, creates a realism that draws on the theories of non-figuration. Compared with non-figurative compositions in which line, form and color play out their own metaphorical realities on the surface of works through tensions, contrasts, intersections and spatial effects, Lorentzen's compositions verge on abstraction. The significance of the works resides in the interrelationships between the furniture and the space.

"The room I paint becomes an unreal reality."[6] This statement by Lorentzen can be interpreted as both an expression of painting's autonomy as a work of fiction and as proof of the artist's belief in her painting's existence as a symbol of non-visible reality. In Lorentzen's work, the tradition of the interior has shifted from outer to inner space. In a certain way, her work actually seems closer to still life than interiors. Yet, even as still lifes the images diverge from earlier traditions, for the objects displayed do not have culturally coded references we all can understand. There is no fruit or flowers, no game or fish, no sensual display or vanitas decay. On the contrary, her objects are new to us and their meanings are private. They reflect Lorentzen's concept that art is a retreat from reality, or a free space for the subject of one's choosing.

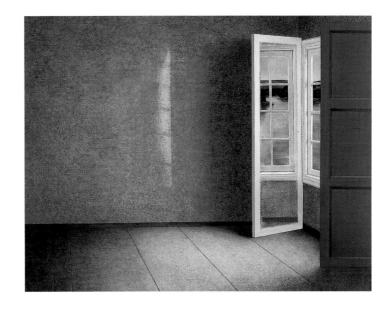

IDA LORENTZEN
My Light Burned for Seven Days and Seven Nights (1993)
Oil on canvas, 55 x 71 inches
Courtesy of Babcock Galleries, New York
Photo: Bengt Wilson, Oslo

Lorentzen's images are of her own house at Oslofjord, the house in which she spent her summers as a child. One room of the house serves as both studio and model, with the furniture acting as building blocks in the construction of a "home" for the inner self. Lorentzen sees furniture and architecture as substitutes for people and human relationships: "The room is the framework of our lives. It is the room in which we exist. The floor is our foundation. The walls our limitations. The door is the authoritative and masculine. It can close. Abruptly. When open, we sense another room. The table I associate with the feminine. It welcomes us. The chair is the I. Its construction fits you and me."[7]

To all outward appearances, the pieces of furniture Lorentzen chooses to paint are clearly defined in the brightly lit room, motionless and under strict control. These assemblages often face the viewer, presenting a full view of a rather intimate sphere. Nevertheless, a distinct distance is maintained in a silence, a pressured sort of calm that feels like a rubber band held still but under tension. The room is a bit too close; the furniture takes up more space than it should; the door is larger than the doorway; the mirror's reflections violate the laws of perspective. A glimpse of a fjord landscape appears in the mirror. Each impression or perception must be filtered through the logic of the inner room before it can find its place. Everything is carefully placed and delineated, and yet, an undertone of instability remains, held in check by the sharp clarity of the room. What seemed initially to be an open room has closed in on itself. It now offers only peepholes to the out-side world which merely serve to emphasize the feeling of claustrophobic enclosure.

As in Kristin Ytreberg's work, Lorentzen's room is the site of continuity and development. Often the same furniture appears in new juxtapositions, encountering new elements. The objects sometimes stand alone, or they are placed close together in harmonious pairs or groupings or they are rearranged in more tense and complex compositions. In this way previous "experiences" are carried along in a continuum from painting to painting, the past always freighting the present. The evolution of Lorentzen's paintings is slow and painstaking, which cannot help but foster the impression that every addition to her body of work is mired in entropy, that the past consumes the future.

A series entitled *The Story of Seven Paintings* from 1993–94, represented in this exhibition, exemplifies this point. The series opens with *Room with a View* and ends with *Rise Up and Your Reflection Will Attend* (cat. 26). The titles suggest a journey from an outward, open attitude to an inward confrontation with one's self. The ostensible subject of the first three paintings is a landscape view reflected in a mirror. In *Room with a View* the landscape is centrally placed within a harmonious space. In the two subsequent paintings, the view competes with more pieces of furniture which are, nonetheless, carefully ordered. The fourth painting, entitled *My Light Burned for Seven Days and Seven Nights,* is devoid of furniture. Painted in a darker tonality, it can be interpreted as an existential moment of exhaustion—the moment which immediately precedes a new direction

the artist will embark upon in the final three images of the series.

In these final paintings, windows and mirrors which Lorentzen has used to expand the room's space are exchanged for reflecting sheets of glass lying flat on the floor. The room becomes more unreal. Reflections sink into the horizontal plane of the floor and also emphasize a new vertical element in the painting—a tall, triangular clothing rack. While the door previously functioned as the "authority" figure (both as a barrier and possible exit point), the clothing rack now appears almost like a lighthouse among the low stools and end tables. According to the artist, the rack is "a monument to the upright human being." It stands tall and independent, yet creates an ambiguous impression overall, which is emphasized by the dark shadows cast upon the wall behind it. In the painting, *He Is Not Dead; He Is Only Sleeping*, the shadow forms a cross on a table like a premonition of death (cat. 25). Similarly, the downcast reflection in the dark room hints at an abyss. If, in Lorentzen's paintings, the walls and floor are understood to provide a secure support for constantly changing interior arrangements, these last three paintings suggest that the framework itself is mutable and can be destabilized by the contents of the interior. Not only can the past invade the present but the reverse is true as well.

Although there is no human presence in Lorentzen's room, there is a latent reference to the human skin in the floor and wall surfaces. Painted in layers of color which range from warm base hues through cold tones, the entire canvas is then covered by a transparent glaze which allows the various layers to show through its evenly speckled surfaces. This skin-like background adds an overall vibrancy to an otherwise dead still life. This is again an example of the tension Lorentzen creates between realism and symbolism. Conceived as portraits or self-portraits, one can say that the artist's method enables her to paint the corporeal body into the picture. She describes the transition from the outer to the inner room precisely and simply: "The room houses the body, the body houses the soul."

An interest in intimate objects and a devotion to maintaining social relationships has traditionally been associated with women's roles within the home. Looking at the work of women painters at the turn of the century seems to confirm this tendency to depict motifs from the domestic sphere. To paraphrase Anne Wichstrøm, women's themes seldom moved outside the garden wall. There also is some truth to the statement that Kristin Ytreberg and Ida Lorentzen represent a continuation of this tradition through their choice of the interior as the focus for their artwork, even though today's conceptual and artistic context is entirely different. Portraying tangible reality was inherent to 19th-century realism and women's depiction of interior scenes seemed to offer an unproblematic insight into the domestic sphere inhabited by their friends and other members of the bourgeois class.

While interior painting cannot be called a female genre strictly speaking, in European art history women artists typically have concentrated on interior painting, still life and portraiture. These were genres that were accessible to

women, given their position in society, while historical and religious paintings were largely the domain of men. When Lorentzen and Ytreberg choose subjects from the domestic and private spheres, they do so for other reasons, however. While it may seem natural for them, as women, to base their work on their immediate surroundings, the very theme of their works transcends the traditional interior's narrative limitations, projecting a symbolic or poetic meaning beyond the space that they describe. Somehow they allude to the bourgeois notion "my home is my castle," stressing the free reign of the individual. But in their work individualism is transformed into an existentialist experience of the inner self.

The Female Figure in a New Guise —Hanneline Røgeberg, Hege Nyborg and Line Wælgaard

Hanneline Røgeberg, Hege Nyborg and Line Wælgaard have a different relationship to artistic tradition than Heske, Ytreberg or Lorentzen. In their search for new critical meanings for their art, these artists have seized upon predominantly male domains of history and figure painting. They reformulate this tradition with a critical attitude, creating new paintings and photographic tableaux based more or less openly on women's issues, gender roles and feminist theory.

Hanneline Røgeberg paints large nude figures in a style reminiscent of paintings from the late Renaissance and early Baroque periods. In spite of, or perhaps because of, this connec-

tion to tradition, the paintings represent a shocking breach of convention, particularly in the presentation of the naked body, most often female. Røgeberg's women are large, powerful and fleshy—the ideal of the beautiful has given way to an urgent, almost grotesque, realism in her exaggerated mannerist bodies. Her art punctures the historical premise of the nude, in which nakedness is clothed in an aesthetically pleasing and enticing robe.

Røgeberg takes a critical attitude toward the nude as object of the male gaze, or, as Kenneth Clark expressed it in his 1956 study *The Nude*, a locus for aesthetic meditation. Instead, she wishes to break what she perceives as a watertight hull, making her figures leak and bleed, so that they no longer maintain their conventional, aestheticized distance. Her paintings include groups of two to four people in dramatic encounters, skin against skin. Depicted in ambiguous embraces, their bodies are inextricably linked in intense interpersonal situations that mimic combat and rape images found in Renaissance and baroque art. Furthermore, the figure groups are arranged architectonically in geometric forms such as triangles, arches or rectangles, that also remind one of earlier artistic conventions. The postures, however, are impossible to believe in all their physical presence, thus undercutting any sense of realistic narrative as found in "old master" paintings. Røgeberg's paintings appear, instead, to portray the physical consequences of psychic events. Life experiences from birth to death, psychological states and the passage of time are etched into the figures' flesh and posture. An overall impression of ennui and vulnerability

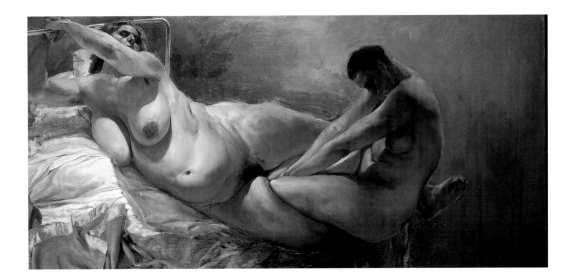

contrasts with the figures' monumentality.

By creating figure groupings using only one gender, usually female, the artist avoids the predictable heterosexually charged world of male/female relations. Rather, the paintings deal with generational oppositions, such as mother/daughter, youth/age, or they depict behavior patterns, such as victimization, love and oppression, weakness and strength, nurturing and violence. Who does what to whom in these different relationships is uncertain and, seemingly, interchangeable—a process which generates an increasingly complex set of human dynamics.

In Røgeberg's paintings, the linear concept of time is altered in several significant ways. The nakedness of the figures, their exaggerated proportions, the lack of attributes to link them to a specific time or place and the mythic landscapes that serve as backgrounds remove Røgeberg's imagery from any known historical context. Her figures function as symbols, allegories or mental constructs rather than real people. Nevertheless, they are disturbingly close and tactile, disquieting perhaps because, as

HANNELINE RØGEBERG
Ex-it (1993)
Oil on canvas, 48 x 96 inches
Courtesy of Diane Farris Gallery, Vancouver

adult beings, they can't help but maintain their physical and sexual markings despite themselves. With introspective, somnambulant expressions, they seem to have reached an instinctive state, like the world of children before they become aware of their bodies as separate from the (m)other. In this state, they express a duality that refers to their development from child to adult, in which the adult/child relationship reverses itself. Marked by life's wisdom, they behave simultaneously like infants, abandoned to powers within themselves which are completely beyond their emotional or rational control.

For Røgeberg, the skin is not a demarcation between the body and the world but a permeable boundary. The skin symbolizes the place where fixed behavior patterns can be altered. By means of such skin "leakages" she attempts to reconfigure polar opposites, so that the boundaries between right and wrong, innocence and guilt, good and bad become unclear. Compared with Ida Lorentzen's symbolic representation of the relationship between space /body and soul, Røgeberg's merging of the body's outward history and inner life is a diametrically opposite solution. In Lorentzen's work the "skin" or space is a permanent protective frame; in Røgeberg's it is a vulnerable sheath subjected to change and cyclical ephemerality. Reflecting different approaches to an existential problem, one seeks clarity in rationally controlled arrangements, the other in psycho-biological confrontation. The paintings of both artists share, however, a longing for the unattainable, which is constrained and thwarted by the imagery's inherent stubbornness.

Hanneline Røgeberg moved from Oslo to the United States at the age of nineteen, receiving instruction in art at the San Francisco Art Institute and at Yale University during the 1980s. Her contact with the Norwegian art world has been slight, and although her painting style might be associated with the neo-romanticism of Odd Nerdrum and his students, Røgeberg has worked without direct connection to them and from a markedly distinct, feminist, point of view.

She began to paint figuratively in 1986, after having attempted to conform to a strictly non-figurative approach during her studies in San Francisco. She says that the opposition she encountered was the most important incentive for her development of painterly figuration. Toward the end of the 1980s she experienced a crisis brought on by discussions of postmodern cultural theory in relationship to painting, both contemporary and traditional. She read feminist theory, art history and revisionism, but found much of the art related to the postmodern theoretical constructs to be self-affirming. She reached a point at which she acknowledged the foundation of her art to be the feminist tradition, although it was also important to work independently of it.

The expressiveness of her art, and the spontaneous empathy it engenders, differentiates it from typical postmodern painting, which assumes an ironic stance that fragments, distances and makes explicit the fictitious nature of the work. Furthermore, her references to old master paintings are not direct quotations, in contrast to the work of many postmodern artists who appropriate images directly from art

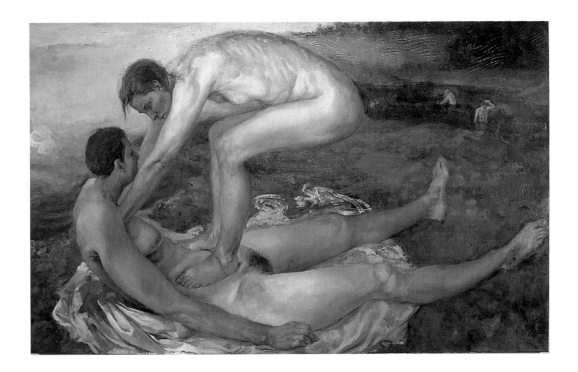

HANNELINE RØGEBERG
Impossible up (1993)
Oil on canvas, 60 x 96 inches
Courtesy of Diane Farris Gallery, Vancouver

history as the basis for their work. On the other hand, Røgeberg's paintings do not pretend to provide an illusionistic reality. She consciously punctures illusionism, through painterly brushwork, strange juxtapositions and cut-off images in her compositions.

Røgeberg's paintings seem to be an especially pointed reformulation of tradition in light of the history of the female nude. From a feminist perspective, her female figures clearly break with the stereotypical representations of the naked female body in Western art history. In *The Nude: A New Perspective* (1989), Gill Saunders studied the differences in presentation and function between the female and the male nude, finding that the woman is consistently depicted as a symbol of sexuality, created as an image for the male eye and male desire. This holds true regardless of the context in which the nude appears, whether in an idealized, mythological context or linked to sexual

temptation and Christian concepts of sin. In both cases women are temptresses, although with opposite intentions and connotations.

Patriarchal tradition defines sexuality in polarized conceptual pairings, such as active/passive, dominating/submissive, masculine/feminine. The representation of the female and male nudes reflects this attitude toward gender roles. John Berger's oft-quoted "men act and women appear" identifies the key point at which feminism rejects the patriarchal definition of the female body as object—passive, susceptible, accessible.

Hanneline Røgeberg's females do not fit in this traditional schema. Her women can hardly be said to pose, and they do not project eroticism, even though their sex is exposed. They are active and subservient, often simultaneously. As with many traditional female nudes, their eyes are lowered or turned away from the viewer, who is given free license to gaze undisturbed. In Røgeberg's work, however, the viewer is placed in the same position as the figure who is portrayed, and may feel ill at ease with this relationship.

The body as landscape or nature is another analogy which reflects the dualistic thinking that equates woman and nature versus man and culture, the fleeting and uncontrollable versus the controlled.

Røgeberg retains the analogy of the body as nature, not in its dormant state or as a threatening force, but by establishing the biological clock and the psyche's connection to bodily functions as fundamental premises for human life. The emphasis on body/nature results in an elevation of the female principle,

and in the process she reunites the body and soul.

In the post-war period the convention of the nude has been redirected and reshaped based on new artistic and socio-theoretical attitudes, including feminist criticism. As Saunders has noted, most of the artists in the 1980s who broke with traditional female stereotypes employed art forms other than painting. These alternative media, such as photography, video and performance art, generally stood outside the art historical mainstream and, therefore, were not burdened with conventional associations and connotations about the nude. Røgeberg says that, in the beginning, she had misgivings about attempting to paint the female body, but decided to press forward with her ideas about recasting and redefining the image of the nude. As is the case with many other women artists, her work attempts to nullify the male gaze by de-eroticizing the body, emphasizing its biology and relation to specifically female experiences instead.

Contemporary explorations of gender, sexuality and identity often stimulate artistic projects which comment upon and debate the relationship between female identity, art and mass media. Hege Nyborg and Line Wælgaard are more directly involved with these issues than Hanneline Røgeberg. As such, their art's dispassionate blend of postmodern and feminist theories links them with international artists such as Mary Kelly, Cindy Sherman and Laurie Simmons. Nyborg, for example, works with the strategies of deconstructivism to confront and relativize our inherited societal attitudes toward the female body and women's natu-

re. In Nyborg's paintings and drawings, "woman" is characterized as "the other"—an objectification of male desires and ideals based on her position as man's subordinated alter ego. In order to combat and refigure the effects of this withering otherness under the male gaze, Nyborg's women are presented as a masquerade; her painting's images and words act like a veil which hides or masks women's true identity from the viewer and must be deciphered.

Nyborg views her paintings as texts to be read and she often uses historicist references to art of the past to distance her own role as artist. Her ideas about the relationship between the artist, the work and the viewer is very different from that of Hanneline Røgeberg, for instance. Røgeberg's feminist-based paintings continue to assert the work's inherent unity and authority as an expression of the artist's individuality and personal signature. Nyborg's postmodernism requires the viewer to search for the meaning of her fragmented words and images used, all of which have been isolated from their original historical contexts within a new "art"ificial construct. Ultimately the content of Nyborg's art depends on the viewer's abilities to interpret her texts, while the artist's ego retreats into the background.

Her paintings' historical sources and references are far from stable elements, however. Since they are re-presented in a new work of art, they retain a reminder of their original historical context and yet are drained of their original significance. They have become visible signs on the painting's surface surrounding a content which is now invisible and behind that surface. To a point Nyborg follows Marcel Duchamp's assertion that art is not what can be seen but what arises in the spaces between. She also has allied herself with Duchamp's theories about language and image, as a means of destabilizing the traditional dichotomy between the masculine and the feminine and the values and traits that are assigned to these principles.

Nyborg's work focuses on the female body, often starting with eroticized images of women which invite unrestrained male voyeurism. *In the Garden of Eden* is the title of a diptych from 1992 (cat. 27). In the first panel, the artist presents a paraphrase of rococo painter François Boucher's painting *Hercules and Omphale*. On the other, she reproduces a view of the gardens of Versailles, designed in the 18th century by André Le Nôtre. On top of these images, Nyborg uses a slide projection to create a transparent screen of text borrowed from Jean-Jacques Rousseau's *Confessions* (1766–70). The combination of such images and text enables Nyborg to create a new context for the historical references: they become symbols in her revisionist visual and linguistic discourse.

Created for the French court at a time when "no play [was] nobler or more beautiful than the gratification of the flesh," (Henri de Régnier, *Amorous Copperplates*), works such as Boucher's voluptuous, semi-pornographic "alcove ladies" are perfectly suited to Nyborg's project. In her paraphrase of Boucher's art, Nyborg's emphasis of Omphale is a particularly blatant case of role reversal. In this myth Hercules spent one year in servitude to the Lydian queen Omphale. During this time he was known to have dressed as a woman and was asked to do woman's work—weaving, spinning

and even, Boucher suggests, making love to Omphale in a subservient role. According to various accounts, although Hercules submitted patiently to this trial, as was Zeus's will, he felt degraded by his punishment.

Despite the sense of female empowerment inherent in this ancient myth, Boucher's painting insistently refocuses attention on a kind of feminine boudoir sensuality characteristic of French rococo painting. Nyborg, in contradistinction, appropriates Boucher's image, tearing the motif away from its voyeuristic rococo past to establish it as a reflection of her own contemporary, critical eye and methodology. With the help of a grid system and overhead projector, the artist transfers selected features of the original painting to her canvas with calculated precision. She cools off the ethereal and atmospheric sensuality by emphasizing the drawn contours of her figures and by toning down the color scale. Finally, she employs a projector once again to shine a page of text from Rousseau's *Confessions* directly onto her painted canvas "screen." The voyeur's vision is thus disturbed by this veil of text, creating a sense of displacement about the scene. The passage quoted adds another layer of complexity, as Rousseau speaks of his adoration of nature, God's creation, and of the woman who, half asleep, receives his "equally pure and tender kiss"—a woman who in her innocence has an "enchantment that never accompanies sensual desire."

Through the addition of Rousseau's text, Nyborg's art reveals the traditional false duality ascribed to the feminine principle, which has continually characterized woman as an incom-

plete human being. For Rousseau, the sleeping female is akin to virgin nature, while awake she becomes an arena for sexuality. Man, however, as the morally active principle, subdues, conquers and ultimately cultivates both woman and nature. In contrast, Nyborg's use of Boucher's Omphale illustrates how man is slave to woman's sexuality based on his own desires. Here, it is the woman who subdues the hero, placing him in a position he finds degrading, yet is unable to resist. Thus the synthesis of the two female personae in Nyborg's art implies a ridiculing and undermining of the age-old patriarchal duality of woman as either Madonna or whore—the good, nurturing earth mother or the intractable witch. Just as the opposition between masculine and feminine is overturned in her use of Hercules and Omphale, so, too, Hege Nyborg disturbs the typical opposition of virgin and whore inherent in the male gaze.

The patriarchal power structure is again upset in the artist's pendant panel for *In the Garden of Eden*. André Le Nôtre's formal gardens at Versailles serve as a symbol of male power and dominance. The gardens, which signify the ordered and rational universe of Sun King Louis XIV, are logically and clearly constructed from geometric shapes along a central axis. As landscape architecture, Le Nôtre's designs may be viewed as a highly stylized ideal of the palace's original natural surroundings.

The grounds present a wide perspective of ornamental surfaces and may be regarded as a conceptual counterpart to Omphale's body, which is painted in the same artificial, golden tonality as the garden. The garden represents

exalted nature. It reflects the philosophical universe of the time, in which man intervenes in nature, using geometry as a sacred ordering principle to reshape the wilderness into something permanent and well organized. The poetic text overlay, once again taken from Rousseau, speaks to "a sincere exaltation of the heart to the Creator of this lovely Nature, whose beauty lay spread out beneath my gaze," which, in Nyborg's depiction, literally refers to Versailles. As such, the meaning of the text is turned into an involuntary tribute to the king and the rationality of his dominion.

Nyborg's use of this symbolic system is again equivocal, however, for she depicts the park without emphasizing its symmetrical axial character. Instead, the artist chooses to show the gardens from an oblique angle, which gives a less ordered impression, as if refusing to allow nature to conform to Le Nôtre's artificial, unified structure. The perspective shifts constantly in her painting, creating multiple points of view and a compositional solution that, for all its seeming rationality, misguides or misleads the viewer. In Nyborg's diptych *In the Garden of Eden*, the female body and nature are shown side by side, representing the feminine—expressive, original, seemingly controlled by the male rationality, but intentionally and effectively subverting patriarchal dualities and simplifications.

Attitudes Passionelles (1994) continues to deal with the issue of female identity and sexuality, and the illusions of male-constructed images of womanhood (cat. 28). The work consists of a series of drawings based on Jean-Martin Charcot's photographs of female patients in

HEGE NYBORG

Detail from *Attitudes Passionelles* (1994)

Drawing on canvas with engraved text on plexi, 17 x 17 inches

Photo: Anders Rydén

HEGE NYBORG

Detail from *Attitudes Passionelles* (1994)

Drawing on canvas with engraved text on plexi, 17 x 17 inches

Photo: Anders Rydén

various stages of hysteria from his famous study *Iconographie photographique de la Salpêtrière* (1876–80). It is interesting to consider the staging of the photographs, in which women under hypnosis—often young and beautiful—demonstrate the third stage of hysteria. They often assume sexually explicit poses, with their hair loosened and their bodies partially exposed, as objects of study for male researchers. In addition to the quotations from Charcot, Nyborg has included several motifs taken from the children's book *Struwwelpeter*, first published in 1845 by Heinrich Hoffmann, a physician in a Frankfurt insane asylum. Hoffmann's instructive tales reveal a grotesque set of "exemplary punishments" of disobedient children—a boy who will not stop sucking his thumb has it chopped off; a girl who continuously plays with fire sets fire to herself. In these scenes as well as Charcot's dramas, Nyborg reveals and reinterprets society's restrictions on sexuality through an examination of 19th-century moral codes for women and children.

Since earliest times hysteria has been linked to female sexuality. The term was developed by Hippocrates from *hystera*, the Greek word for uterus. In fact, for many years it was thought that hysteria was a symptom of a detached uterus. The concept of hysteria is associated with other words connoting a sexuality that has difficulty defining itself. In Nyborg's work the artist emphasizes the hysterical body as a means of escaping the coercive pressure of society, revising its conventions and dissolving its restrictive constructs of gender, identity and desire.

The *Attitudes Passionelles* drawings are framed in individual, cell-like boxes. Acrylic

sheets, etched with text fragments, overlay the drawings like a shadowy membrane laid over the image or demographic symbols etched onto the body. The entire series is mounted against a turquoise background. The concept of the work builds upon studies in which scientific and literary texts are placed next to the visual source material. Every feature of the work resonates with references to hysteria as a psychological and physiological phenomenon, from Sigmund Freud's and Josef Breuer's studies to stories of women's fates described by George Eliot, Gustave Flaubert or Émile Zola. The texts by these authors are not directly quoted in her works, but exemplify some of the study material she includes in her working process. Thus *Attitudes Passionelles* stands out with its own poetic expression, visually fragile and almost transparent, with historical and literary references that become a form of memory consisting of free-flowing and half-forgotten recollections.

In a second version of *Attitudes Passionelles* (1994) she quotes an excerpt from Marcel Proust's *Remembrance of Things Past*. Here, the theme of woman/nature is again captured by Nyborg and linked to the Charcot patients' hypnotic states. Proust's text speaks of the exalted love awakened in the author as he observes a sleeping woman. She is compared to a plant and in her deepest sleep to a landscape. Not until she is asleep and exposed before his eyes does he feel that he owns her completely, her dreams and her unconscious body, like a landscape that he can capture. Like Charcot's hypnotized patients, it is only in the subconscious state that woman achieves her true nature, which is then dominated by Proust's fully conscious observer/voyeur.

Nyborg's depictions in *Attitudes Passionelles*, as well as the advent of feminist and postmodern theory, permits us a different view of Charcot's photographs than was possible in his day. Several of them, for instance, display life-affirming expressions and erotic pleasure more than insanity. They are also encircled by a 19th-century historical context which made them prisoners without identity by virtue of the double standard of the Victorian age—one which repressed bourgeois female sexuality in the name of family values yet rewarded male libidinous urges through a shadow system of courtesans and other demimondaine. Women from both these worlds who did not conform to the rules were often incarcerated.

An overarching theme of both *In the Garden of Eden* and *Attitudes Passionelles* is the representation of the female figure as it is shaped by the male eye—openly displayed to the voyeuristic view. Nyborg's art interrupts this process, however, arresting the gaze and reflecting it back in a new form, not purely as a mirror but as means of making the very act of seeing conscious and confrontational. The artist's strategy is a way of questioning power structures that manifest themselves in bodily symbols. What is described as a lack of sexual identity through the spectacular stage setting in Charcot's work can be compared to the definition of the body in our time. Nyborg's work is not just about attitudes from the past. Equally important, it is about recognizing how those attitudes have been passed on and continue to live in the present. The posed, idealized images of women

in contemporary advertisements and our current obsession with beautiful bodies and body-building might be called a kind of late 20th-century collective hysteria. Fashion models, those icons perfection, can be viewed as the new social and sexual straightjacket for today's women.

In terms of Norwegian art, Hege Nyborg's work has no antecedents. It is particularly distinctive because of her conceptual attitude and emphasis on intellectual clarity. Given the background of strong painterly, expressive and romantic styles in Norwegian tradition, she was exploring new territory already as a student in Oslo in the 1980s. At that time she had finished university courses in political theory and philosophy at Amherst College in Massachusetts. She later attended the art academy in Vienna before completing her art education at the academy in Oslo in 1988–91.

Line Wælgaard's work has similarities to that of Nyborg in her manipulation and staged arrangement of images weighted with art historical references, myth and symbolism. While Wælgaard also has chosen women's issues and

LINE WÆLGAARD
Untitled (1991)
C-print, 50 x 148 ¾ inches
Collection of artist
Photo: Line Wælgaard

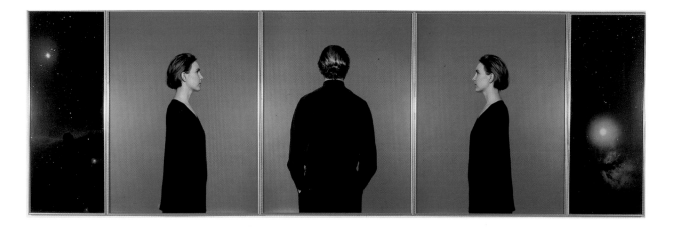

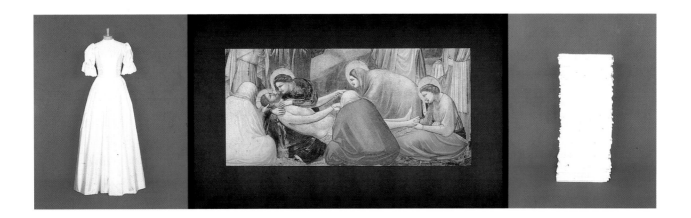

gender roles as her theme, her approach is fundamentally more intuitive. As mentioned earlier, Wælgaard's postmodern images using borrowed historical references, costumes and props creates a confrontational dialogue between the artist's subjective authority and the viewer. Wælgaard, a trained photographer, says that photography's traditional place outside the art world initially made it easier for her to avoid the pressure of "van Gogh's ear and the myth of the artist."

After studying photography at technical college in Oslo in 1984–85, she continued her art training in Stockholm until 1989. She became interested in the work of Cindy Sherman quite early, at the same time that a spirited and rejuvenating debate about postmodernism was occurring in Swedish cultural circles. This period had a strong impact on Wælgaard, turning her attention away from the more traditional aspects of fine art photography.

Stabat Mater (1991) and *Amor Fati* (1992) are triptychs, both of which contain a central image taken from the sphere of religious art. In *Stabat Mater*, Giotto's well-known, revolutionary fresco *The Lamentation* (Padua) is reproduced on a large scale and cropped to focus on the grieving women surrounding the dead

LINE WÆLGAARD
Stabat Mater (1991)
Light boxes, duratrans, 48 ½ x 153 inches
Collection of artist
Photo: Line Wælgaard

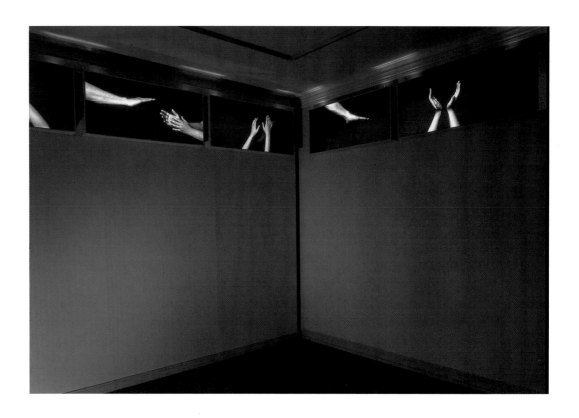

body of Christ. Without hesitation Wælgaard appropriated one of the central icons in the history of Western art to focus on an archetypal image of woman in our culture—the mother role in its loving, nurturing function. The picture is flanked by two clear symbols linked to the motherhood in modern bourgeois life: a white bridal veil (indicative of the "queen-for-a-day" experience of the wedding and the transition to motherhood) and a stack of white sheets (a symbol of a mother's sacrifice and despair in the repetitiveness of daily life).

In spite of the clarity of the imagery in *Stabat Mater*, its meaning is ambiguous. There is no glorification of the mother's role, it is simply presented without the artist's taking an obvious position. The work is provocative, however, in the way it collapses the boundaries of biblical history, Christian iconography and

contemporary culture while exploring the telegraphic qualities of the imagery far removed from any religious context. At the same time, the unexpected juxtapositions remind one that the original content of many early religious and mythological works of art have become undecipherable or are hidden from the public of today. We no longer know the codes for reading the images without going to historical sources. Yet the pictures convey fundamental human themes and moral norms that continue to be relevant today.

Wælgaard has stated that her use of religious references was spurred by what many acknowledge today as the malaise of the Western world—the loss of meaning many experience after the security provided by religious affiliation has disappeared. Thus what is significant about Wælgaard's work is its mythic value and historical resonance in dialogue with other symbols linked to women's lives. The fact that she uses well-known Latin expressions for the titles also functions as an entry to a religious atmosphere.

Amor Fati addresses a theme similar to that of *Stabat Mater*, but shifts the attention to women's roles as victim and martyr (cat. 31). The central motif is a photographic paraphrasing of a 17th-century Italian painting of St. Agathe. Carefully posed and clothed, the model holds a blood-soaked cloth to her breast, a device which in the original painting was an attribute of St. Agathe's martyrdom. According to one source, Agathe was executed after refusing the proposal of a Roman consul, who avenged himself by mutilating her breasts—the emblem of her femininity.[8]

This literary meaning is diffused in Wælgaard's photograph, which takes on a peculiarly mysterious character. Without knowledge of St. Agathe's fate, the meaning of the image shifts toward a different type of ritual, with the blood at the center symbolizing breached virginity, the menstrual cycle or fecundity. The close-up of a red steak in one of the triptych's side panels implies the bodily aspect, while the red roses on the other side picture—an extremely ambiguous symbol—suggest love, life, creation and beauty. By framing the circular images in a wreath of sharp barbed wire or sword-like protrusions, Wælgaard shifts the associations back to pain and a martyr's death, which is the traditional connotation of rose thorns. On the whole, however, the frame is experienced more as a defense or as a statement that is often attributed to women: don't touch me.[9] Understood as an ironic expression of female sexuality, *Amor Fati* represents a proud assertion of the female gender, not as a sex object but as a reality based on women's own experience.

Visually the triptych is startlingly clear. It strikes the viewer with the same force as big advertising posters, which seduce us with their aesthetics and insistence on depicting reality as more real than the eye is prepared to register. Technically, Wælgaard's work approaches the perfection and high resolution of the advertising photo. It remains interesting that this hyperrealistic approach to the theme still results in tableaux that refer to an imaginary realm.

As part of a younger generation of women artists, who have tended to include women's

issues in their work, Wælgaard, Nyborg and Røgeberg have chosen a viewpoint which clearly differs from the political, economical and social concerns of the Women's Liberation Movement of the 1970s. Rather than focusing on women's actual life in society, they immerse themselves in an imagery of the past and representations of the female body. They confront tradition with a different theoretical perspective, bringing forth new images and questions about the ever-intriguing relations between body and mind, representation and identity.

With regard to figuration in art, and particularly the mainstream tendency in the Norwegian figurative tradition, the general viewpoint of the contemporary artists in this exhibition seems like a shift of ground. Somehow the artists seem closer to their forebearers from the late 19th century than to their immediate predecessors of the 1970s. Art historical shifts often have been characterized by opposite poles, such as romanticism versus realism or expressionism versus conceptualism. With these terms in mind, the contemporary artists, with their self-reflexive and sometimes conceptual attitudes, appear to join with the "truthfulness to reality" of Backer, Kielland and Nørregaard to an unexpected degree, although their focus is markedly different. Whereas Norwegian artists of the past, however, cast what they thought was an objective eye on the surroundings and life of their times, contemporary artists realize that their creative endeavors are conditioned by their own experiences, as well as societal and theoretical constructs.

Notes

1 Jakob Weidemann was the most celebrated abstract artist. Important women artists of the post-war generation were Inger Sitter, Gunnvor Advocaat, Anna-Eva Bergman and the sculptor Aase Texmon Rygh.

2 Per Kleiva, Willibald Storn, Marius Heyerdahl and Kjartan Slettemark were among the radical young artists of the 1960s, challenging the established art norms.

3 Odd Nerdrum, who painted in the "old masters" style, is a central figure of this movement to the present day. Frans Widerberg was noted as one of the traditionalists. In the 1970s he developed an expressionistic style and is numbered among the best-known contemporary artists in Norway.

4 Quoted in Kim Levin, "Marianne Heske: Power Stations" from *Marianne Heske*, exhibition catalogue (Bergen: Bergens Kunstforening, 1993).

5 In this respect the electronically manipulated video recording convincingly represent abstract expressionism, which in Norway is incorporated in the landscape tradition as "impressions from nature." Heske departs from tradition on one significant point, however. There is no personal handwriting, no flourished stroke as a spontaneous imprint of the artist's ego. This does not necessarily mean that she is not present in the work, for she is the one who guided the process of its creation. This subject is discussed by Gunnar Danbolt in "Fra symbolets identifikasjon til allegoriens distanse," *Kunst og Kultur* no. 2 (Oslo: Universitetsforlaget, 1994).

6 Ida Lorentzen, *The Story of Seven Paintings* (Oslo: Gyldendal Norsk Forlag, 1994), 20.

7 Lorentzen, *The Story of Seven Paintings*, 24.

8 Gertrude Graces Still, *A Handbook of Symbols in Christian Art* (New York: Collier Books, 1975).

9 The theme is continued in Wælgaard's work *Noli Me Tangere* (1993), which alludes to the biblical story of Christ and Mary Magdalen.

Marianne Heske

1946

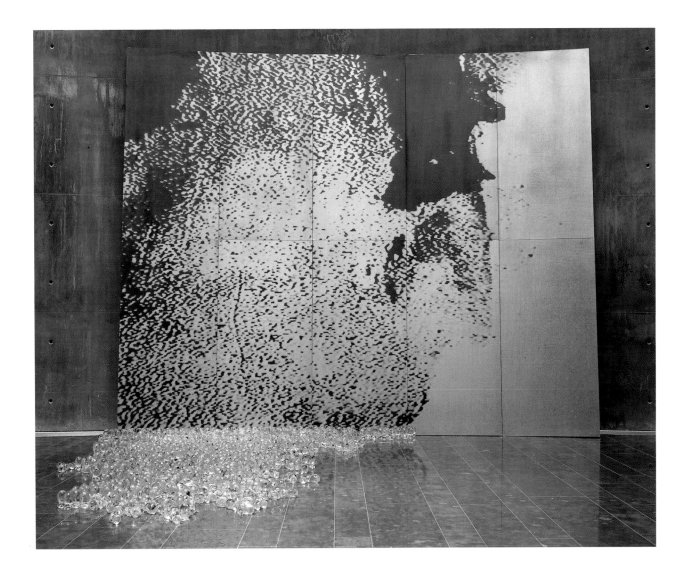

21 Marianne Heske

Avalanche (1993)

Installation, video-painting on sandblasted metalplates + 1001 hand cast crystal doll heads, 157 ½ x 197 inches

Collection of artist

Photo: Øistein Thorvaldsen, Oslo

Ida Lorentzen

1951

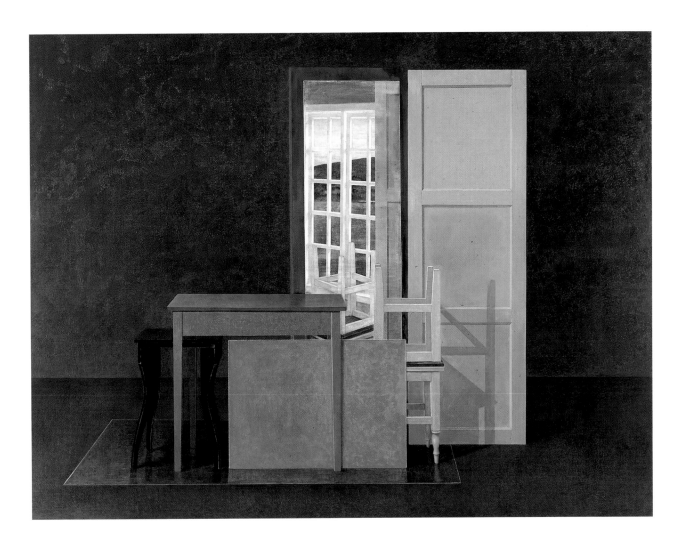

22 IDA LORENTZEN
 Life Size (1994)
 Oil on canvas, 89 x 114 inches
 Courtesy of Babcock Galleries, New York
 Photo: Bengt Wilson, Oslo

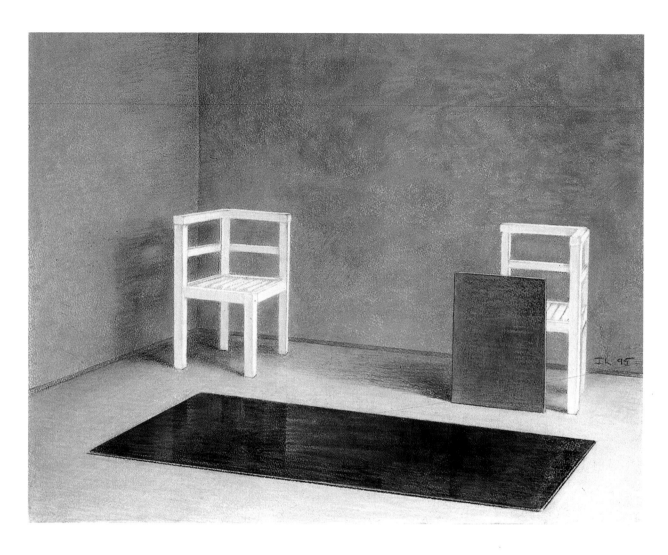

23 IDA LORENTZEN

To Ask is to Have Where Answer is Given (1994)

Pastel, 19 ¼ x 24 ½ inches

Courtesy of Babcock Galleries, New York

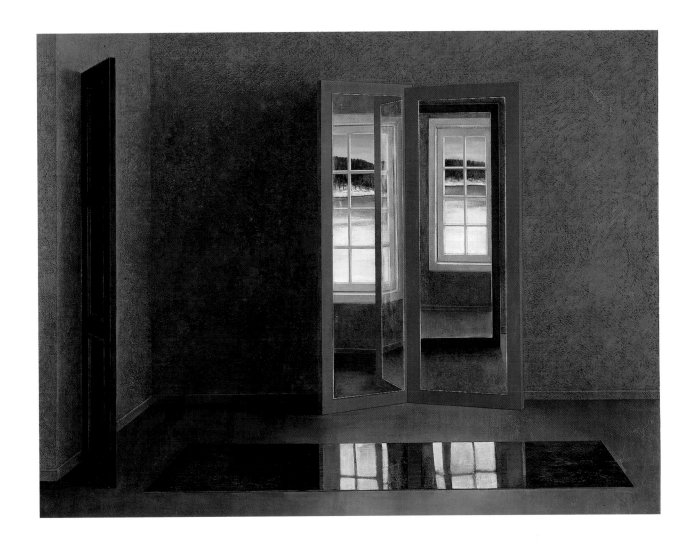

24　IDA LORENTZEN

The Empty Cross (1994)

Oil on canvas, 51 ¼ x 67 inches

Private collection

Photo: Bengt Wilson, Oslo

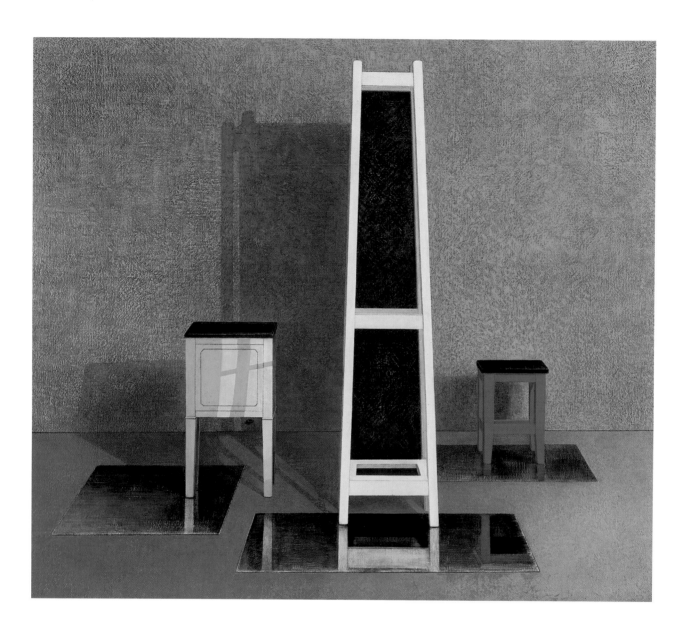

25 IDA LORENTZEN
 He is Not Dead, He is Only Sleeping (1994)
 Oil on canvas, 51 ¼ x 59 inches
 Courtesy of Babcock Galleries, New York
 Photo: Bengt Wilson, Oslo

26 IDA LORENTZEN

Rise Up and Your Reflection Will Attend (1994)

Oil on canvas, 53 x 67 inches

Courtesy of Babcock Galleries, New York

Photo: Bengt Wilson, Oslo

Hege Nyborg

1961

27 HEGE NYBORG

In the Garden of Eden (1992)

Diptych, oil on canvas with projected text, each 17 ¾ x 53 ¼ inches

Trondhjems Kunstforening, Trondheim, Norway

Photo: Hege Nyborg

28 HEGE NYBORG

Attitudes Passionelles (1994)

8 drawings on canvas with engraved text on plexiglass, each 17 x 17 inches

Collection of artist

Photo: Anders Rydén

Hanneline Røgeberg

1963

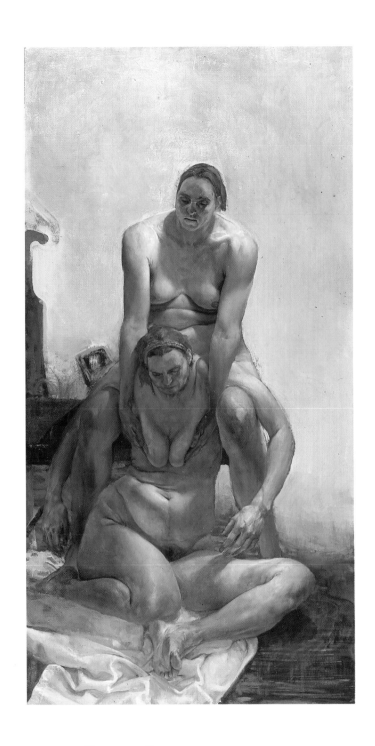

29 HANNELINE RØGEBERG
 De-Generation (1993)
 Oil on canvas, 102 x 54 inches
 Courtesy of Diane Farris Gallery, Vancouver

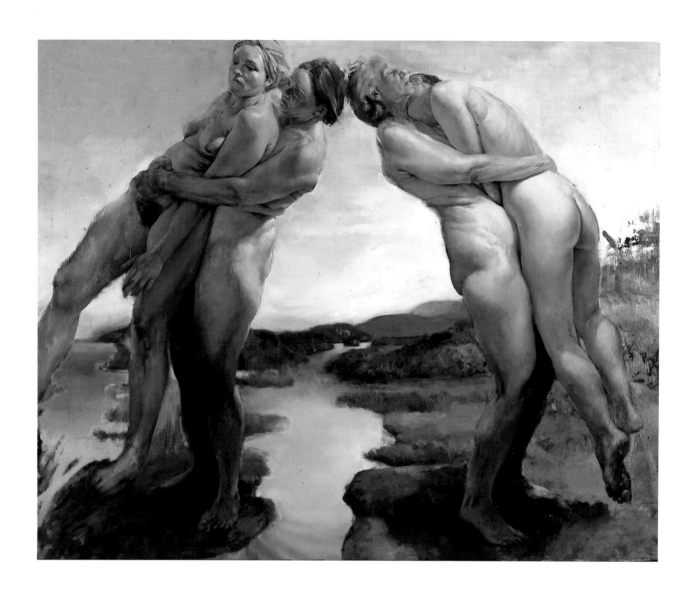

30 HANNELINE RØGEBERG
Untitled (1993)
Oil on canvas, 84 x 96 inches
Vancouver Art Gallery

Line Wælgaard

1959

31 LINE WÆLGAARD

Amor Fati (1992)

C-prints, steel/glass, triptych, each Ø 55 inches

Collection of artist

Photo: Line Wælgaard

Kristin Ytreberg

1945

32 KRISTIN YTREBERG

Transparency (1995)

"Single Room" (1992)

Installation, lead, steel and zink

Haugar Vestfold Kunstmuseum, Norway

Photo: Dag Alveng, Oslo

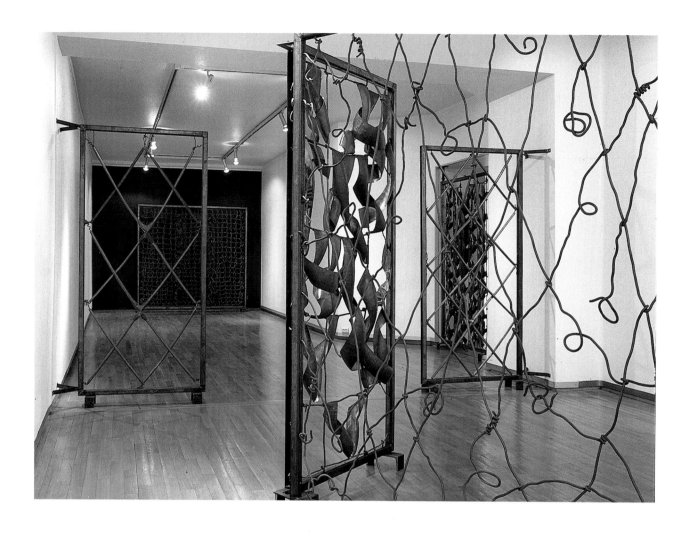

32 KRISTIN YTREBERG
 Transparency (1995)
 "Saturnus'" (1994)
 Installation, steel and lead
 Collection of artist
 Photo: Jamie Parslow, Oslo

32 KRISTIN YTREBERG
 Transparency (1995)
 "Saturnus' 3rd letter" (detail) (1994)
 Lead
 Collection of artist
 Photo: Jamie Parslow, Oslo

Artists' Biographies and Bibliographies

Harriet Backer

Born 1845, Holmestrand, Norway

Lived 1874–78, Munich, Germany

Lived 1878–89, Paris

Died 1932, Oslo, Norway

Education

1878–80 Trélat de Lavigne's Art School, Paris (Jules Bastien-Lepage, Léon Bonnat, Jean-Léon Gérôme)

1874–78 Private student of Eilif Peterssen, Munich, Germany

1872–74 Knud Bergslien's Art School, Christiania (Oslo), Norway

1861–65 J.F. Eckersberg's Art School, Christiania (Oslo), Norway

Solo exhibitions

1983 Blaafarveværket, Modum, Norway

1964 Oslo, Norway

1954 Oslo, Norway

1947 Oslo, Norway

1933 Commemorative exhibition, Oslo, Norway

1925 Oslo, Norway

Bergen, Norway

Stockholm, Sweden

1922 Kristiania (Oslo), Norway

1914 Kristiania (Oslo), Norway

1907 Kristiania (Oslo), Norway

Selected group exhibitions

1989/90 *Rooms with a View,* Milan, Italy; Munich, Germany; Antwerp, Belgium; Schleswig-Holstein, Germany; catalogue

1988 *They Went to Paris,* Stockholm, Sweden; catalogue

1986/87 *Dreams of A Summer Night: Scandinavian Painting at the Turn of the Century,* London; Paris; Düsseldorf; catalogue

1982 *Northern Light: Realism and Symbolism in Scandinavian Painting 1880–1910,* New York; Washington, D.C.; Minneapolis, Minnesota; catalogue. *Women's Images,* Oslo, Norway; Traveling Art Gallery of Norway

1975 *Women and Art,* Oslo, Norway

1893 World's Columbian Exhibition, Chicago, Illinois

1889 World's Fair, Paris (also 1900)

1883–1930 Autumn Exhibition, Kristiania (Oslo), Norway

1880–82 Salon des Beaux-Arts, Paris

1877–1883 Norwegian Art Association, Kristiania (Oslo), Norway

Public collections

Represented in all major public collections in Norway and Scandinavia

Selected bibliography

1995 Marit Lange, *Harriet Backer,* Gyldendal, Oslo, Norway (forthcoming)

1993 Knut Berg, "Naturalisme og nyromantikk", *Norges malerkunst,* ed. Knut Berg, Gyldendal, Oslo, Norway

1990 Alexandra Comini, "Nordic Luminism and the Scandinavian Recasting of Impressionism", *World Impressionism. The International Movement, 1860–1920,* ed. Norma Broude, New York: Harry N. Abrams

1988 Marit Lange, "Harriet Backer och Kitty Kielland i Paris på 1880-tallet", *De drogo till Paris. Nordisk*

konstnärinnor på 1880-talet, ed. Lousie Robbert,
Liljevalchs, Stockholm, Sweden

1983 Anne Wichstrøm, *Kvinner ved staffeliet*,
Universitetsforlaget, Oslo, Norway

1982 Anne Wichstrøm, "Blant likemenn. Søkelys på
Harriet Backer og Kitty L. Kiellands karrierer".
Den skjulte tradisjon, Bergen, Norway

1958 Else Christie Kielland, *Harriet Backer*, Aschehoug,
Oslo, Norway

KITTY KIELLAND

Born 1843, Stavanger, Norway
Lived 1873–78, Karlsruhe and Munich, Germany
Lived 1878–89, Paris
Died 1914, Oslo, Norway

EDUCATION

1883 Académie Colarossi (also 1886, 1887), Paris

1880– Private student of Léon Pelouse, Cernay-la-Ville
and Bretagne, France

1874–78 Private student of Eilif Peterssen, Munich,
Germany

1873–75 Karlsruhe Art School, Karlsruhe, Germany
(Hans Gude)

SOLO EXHIBITIONS

1994 Lillehammer, Norway
Stavanger, Norway

1983 Blaafarveværket, Modum, Norway

1977 Oslo, Norway
Stavanger, Norway

1927 Retrospective exhibition, Oslo, Norway

1911 Kristiania (Oslo), Norway

1904 Kristiania (Oslo), Norway

1899 Kristiania (Oslo), Norway

SELECTED GROUP EXHIBITIONS

1988 *They Went to Paris*, Stockholm, Sweden;
catalogue

1986/87 *Dreams of A Summer Night: Scandinavian
Painting at the Turn of the Century*, London; Paris;
Düsseldorf; catalogue

1982 *Northern Light: Realism and Symbolism in
Scandinavian Painting 1880–1910*, New York;
Washington, D.C.; Minneapolis, Minnesota;
catalogue
Women's Images, Oslo, Norway; Traveling Art
Gallery of Norway

1975 *Women and Art*, Oslo, Norway

1897 Venice Biennale (also 1899, 1907)

1893 World's Columbian Exhibition, Chicago, Illinois

1889 World's Fair, Paris (also 1900)

1885 World's Fair, Antwerp, Belgium

1882–1908 Autumn Exhibition, Kristiania (Oslo),
Norway

1879 Salon des Beaux-Arts, Paris (also 1883, 1887)

1878– Norwegian Art Association, Kristiania (Oslo), Norway

PUBLIC COLLECTIONS

Represented in all major public collections
in Norway

SELECTED BIBLIOGRAPHY

1993 Knut Berg, "Naturalisme og nyromantikk",
Norges Malerkunst, ed. Knut Berg, Gyldendal,
Oslo, Norway

1990 Alexandra Comini, "Nordic Luminism and the

Scandinavian Recasting of Impressionism",
*World Impressionism. The International Movement,
1860–1920*, ed. Norma Broude, New York:
Harry N. Abrams

1988 Marit Lange, "Harriet Backer och Kitty L. Kielland
i Paris på 1880-talet", *De drogo till Paris. Nordiske
konstnärinnor på 1880-talet*, ed. Louise Robbert,
Liljevalchs, Stockholm, Sweden

1983 Anne Wichstrøm, *Kvinner ved staffeliet*,
Universitetsforlaget, Oslo, Norway

1982 Anne Wichstrøm, "Blant likemenn. Søkelys på
Harriet Backer og Kitty L. Kiellands karrierer".
Den skjulte tradisjon, Sigma, Bergen, Norway

1977 Marit I. Lange, "Fra den hellige lund til Fleskum",
Kunst og Kultur, no 2, Universitetsforlaget, Oslo,
Norway

ASTA NØRREGAARD

Born 1853, Christiania (Oslo), Norway

Lived 1875–78, Munich, Germany

Lived 1879–85, Paris

Died 1933, Oslo, Norway

EDUCATION

1879–85 Trélat de Lavigne's Art School, Paris (Léon
Bonnat, Jean-Léon Gerome, Jules Bastien Lepage)
Académie Colarossi, Paris

1875–78 Private student of Eilif Peterssen, Munich,
Germany

1874–75 Knud Bergslien's Art School, Oslo, Norway

SOLO EXHIBITIONS

1984 Oslo, Norway

1925 Kristiania (Oslo), Norway

1913 Kristiania (Oslo), Norway

1903 Kristiania (Oslo), Norway

1893 Kristiania (Oslo), Norway

SELECTED GROUP EXHIBITIONS

1988 *They Went to Paris*, Stockholm, Sweden; catalogue

1982 *Women's Images*, Oslo, Norway; Traveling Art
Gallery of Norway

1975 *Women and Art*, Oslo, Norway

1889 World's Fair, Paris
Norwegian Art Exhibition, Minneapolis, Minnesota

1885 World's Fair, Antwerp, Belgium

1883–98 Autumn Exhibition, Kristiania (Oslo), Norway

1879– Norwegian Art Association, Kristiania (Oslo), Norway

PUBLIC COLLECTIONS

Represented in most major Norwegian collections;
portraits in public institutions

SELECTED BIBLIOGRAPHY

1990 Alexandra Comini, "Nordic Luminism and the
Scandinavian Recasting of Impressionism",
*World Impressionism. The International Movement,
1860–1920*, ed. Norma Broude, New York:
Harry N. Abrams

1988 Marit Lange, "Asta Nørregaard", *De drogo till Paris.
Nordiske konstnärinnor på 1880-talet*,
ed. Louise Robbert, Liljevalchs, Stockholm, Sweden

1983 Anne Wichstrøm, *Kvinner ved staffeliet*,
Universitetsforlaget, Oslo, Norway

1982 Anne Wichstrøm, "Asta Nørregaard og den unge
Munch", *Kunst og Kultur*, no 2, Universitetsforlaget,
Oslo, Norway

Marianne Heske

Born 1946, Ålesund, Norway

Lives and works in Oslo, Norway

Education

1979 Jan van Eyck Academie, Maastricht,
The Netherlands

1976 Royal College of Art, London

1975 École Nationale Supérieure des Beaux-Arts,
Paris

1971 Bergen Kunsthåndverksskole, Bergen, Norway

Solo exhibitions

1995 Galerie J&J Donguy, Paris

1994 Gallery Wang, Oslo, Norway

1993 Künstlerhaus Bethanien, Berlin
Kunstmuseum Düsseldorf, Germany
Bergens Kunstforening, Bergen, Norway

1992 Porin Kunstmuseum, Pori, Finland

1991 Galerie J&J Donguy, Paris

1989 Galleri J.M.S., Oslo, Norway
Le Lieu, Quebec, Canada
Mountains of the Mind, Clocktower Gallery,
New York; catalogue

1987 Galleri Ojens, Gothenburg, Sweden

1986 Henie-Onstad Art Center, Høvikodden, Norway

1985 Galleri Doktor Glas, Stockholm, Sweden

1984 Galerie Art Contemporain J&J Donguy, Paris

1982 Galleri Sct. Agnes, Roskilde, Denmark

1981 Henie-Onstad Art Center, Norway

1979 University of Alberta, Alberta, Canada
Bergens Kunstforening, Bergen, Norway

1978 Galleri Norske Grafikere, Oslo, Norway
Galleri F-15, Moss, Norway
Bonnefantenmuseum, Maastricht,
The Netherlands; catalogue

Selected group exhibitions (mixed media)

1995 *At Century's End: Norwegian Artists and the Figurative Tradition, 1880/1990*, Henie-Onstad Art Center, Høvikodden, Norway; The National Museum of Women in the Arts, Washington D.C.; catalogue
Aquilo, Museum Moderner Kunst, Sammlung Ludwig, Vienna, Austria

1994/95 *Nordiskt Ønskemuseum*, Gøteborgs Konstmuseum, Gothenburg, Sweden
– og vestenfor måne, Astrup-Fearnley Museum of Contemporary Art, Oslo, Norway

1994 *Project for Europe*, Copenhagen, Denmark

1993/94 *Winterland*. Atlanta, GA; Tokyo; Barcelona, Spain; Munich, Germany; Lillehammer, Norway; catalogue

1992 *Il Paesaggio Culturale*, Palazzo delle Esposizioni, Rome

1991 *Det syntetiske bilde*, Kunstnernes Hus, Oslo, Norway
"7 Cities, 7 Countries", Leuwarden, The Netherlands

1987 *Art Ware*, Hannover, Germany; Düsseldorf, Germany

1986 *Biennale di Venezia*, Nordic Pavillion, Venice, Italy

1985 *Dialogue on Contemporary Art in Europe*, Gulbenkian Foundation, Lisbon, Portugal

1980 *Experimental Environment*, Reykjavik, Iceland
Biennale de Paris, Centre Georges Pompidou, Paris

1978 *Landskap*, Henie-Onstad Art Center, Høvikodden, Norway

1976 *Life Styles*, Institute of Contemporary Art, London
La Jeune Peinture, Musée d'Art Moderne de la Ville de Paris, Paris

1975 *Artistes Etrangeres à Paris*, Galerie les Contemporaines, Genval, Brussels, Belgium; catalogue
Espace – Surface, Centre culturel de Limoges, Centre Culturel de Chateeauroux, France

1974 *L'Unique Objet*, Galerie Iris Clert, Paris

 Grands Femmes, Petits Formats, Galerie Iris Clert, Paris

 Realitées Nouvelles, Parc Floral de Paris, Paris

 Grands et Jeunes d'Aujourd'hui, Grand Palais, Paris

SELECTED GROUP EXHIBITIONS
(VIDEO AND INSTALLATIONS)

1991 *Voyage Pittoresque*, National Museum of Contemporary Art, Oslo, Norway

1990 *London Video Arts*, ACME Gallery, London

1986 *Borealis*, DAAD Galerie, Berlin

1984 *Bergen International Festival*, Håkonshallen, Bergen, Norway

1981 *Norsk Billed*, Konsthallen, Helsinki, Finland

1980 *Biennale de Paris*, Centre Georges Pompidou, Paris

1979 *Norskt 70-tal*, Kulturhuset, Stockholm, Sweden

1977 *Video & Film Manifestatie*, Bonnefantenmuseum, Maastricht, The Netherlands

1976 *Video International,* Aarhus Kunstmuseum, Aarhus, Denmark

SELECTED GROUP EXHIBITIONS
(GRAPHICS AND PHOTO)

1983 *IIe Exposition internationale "Petit format du papier",* Brussels, Belgium

 Estetica Diffusa, Salerno, Italy

1981 *Métronom/Artists' Books*, Centro Documentacio d'Art Actual, Bercelona, Spain

1978 *Sieben Graphiker aus Norwegen*, Oldenburger Kunstverein, Germany

1975 *Nordisk Grafikkunion*, Bergen, Norway

1973 *La Jeune Gravure Contemporaine*, Paris, France

1970–80 *Statens Høstutstilling*, Oslo, Norway

PUBLIC COLLECTIONS

Ville de Paris

Bibliothéque Nationale de Paris,

The Museum of Modern Art, Novi Sad, Yugoslavia

Bonnefantenmuseum, Maastrict, The Netherlands

Nordisk Konstsentrum, Helsinki, Finland

Norsk Kulturråd, Oslo, Norway

Ålesund Collection of Fine Arts, Ålesund, Norway

The National Museum of Contemporary Art, Seoul, Korea

Bergen Billedgalleri, Bergen, Norway

Henie-Onstad Art Center, Høvikodden, Norway

Riksgalleriet, Oslo, Norway

The National Gallery, Oslo, Norway

Oslo City Art Collection, Oslo, Norway

The National Museum of Contemporary Art, Oslo, Norway

Parc de la Villette, Paris

Pori Taidemuseo, Pori, Finland

SELECTED BIBLIOGRAPHY

1994 Gunnar Danbolt, "Fra symbolets identifikasjon til allegoriens distanse", *Kunst og Kultur,* no 2, Universitetsforlaget, Oslo, Norway

1993 Hans Albert Peters, "Strahlen-Strömen-Stürzen"; Kim Levin, "Power Stations"; Annette Lagler, "Mensch, Natur, Tecnik als Energiequelle"; Michael Haerdter, "Von der Periphere ins Zentrum?". *Marianne Heske,* Bergens Kunstforening, Bergen, Norway

1989 Robert Martel, "Voyage Pictoresque", *Art Actuel,* Québec, Canada

1986 Marianne Heske, *Voyage Pittoresque*, Oslo, Norway Pierre Restany, "Le regard, une culture active et enquiète". *Voyage Pittoresque*, Milan, Italy Per Hovdenakk, "Northern Poles. Breakaways and Breakthroughs in Nordic Painting and Sculpture of the 1970's and 1980's". Hellerup, Denmark

1984 Marianne Heske, *Video Dialogue*, Kalejdoskop
 editions, Åhus, Sweden
 Marianne Heske, *Project Gjerdeløa*,
 Universitetsforlaget, Oslo, Norway
1982 Grethe Grathwol, Marianne Heske, *North*
 no 11–12, Roskilde, Denmark

1980 E. Hebbe Johnsrud, Gulliksen & Gunnar Sørensen,
 Norskt Maleri 70-tallet, Tanum-Nordli, Oslo, Norway
1977 Per Hovdenakk, "Om Marianne Heske",
 Cras XVI, Copenhagen, Denmark

IDA LORENTZEN

Born 1951 in New York City
Lives and works on Nesøya, outside Oslo, Norway

EDUCATION
1979 National Art Academy, Oslo, Norway
1973 Boston University School of Fine Arts,
 Boston, MA

SOLO EXHIBITIONS
1995 Nordic Heritage Museum, Seattle, WA
 Babcock Galleries, New York, NY; catalogue
1994 Kunstnerforbundet, Oslo, Norway
1993 Das Kurhaus Wiesbaden, Wiesbaden, Germany
1991 Galleri Eklund, Umeå, Sweden
1990 Kunstnerforbundet, Oslo, Norway
1987 Tibor de Nagy Gallery, New York, NY
 Galleri Wang, Oslo, Norway
1984 Tibor de Nagy Gallery, New York, NY
 Galerie Wentzel, Cologne, Germany
 Kunstnerforbundet, Oslo, Norway
1982 Tibor de Nagy Gallery, New York, NY
1980 Galleri Haaken, Oslo, Norway
1979 Galleri Tanum, Oslo, Norway

SELECTED GROUP EXHIBITIONS
1995 *At Century's End: Norwegian Artists and the Figurative
 Tradition, 1880/1990,* Henie Onstad Art Center,

Høvikodden, Norway; The National Museum of
Women in the Arts, Washington D.C.; catalgogue
Norwegian Events'95, The Royal Hibernian Academy
of Arts, Dublin, Ireland
1992 *Compostite,* Oslo Kunstforening, Tegnerforbundet,
 Unge Kunstneres Samfund, Oslo, Norway; catalogue
1989/90 *Rooms with a View: Women's Art in Norway
 1880–1990*, Rotonda della Besana, Milan, Italy; Villa
 Stuck, Munich, Germany; and Schleswig-
 Holsteinisches Landesmuseum, Germany; catalgogue
1988 *Akkurat.* Norrkøpings Konstmuseum, Norrkøping,
 Sweden
 Art of the '80s, Monclair Art Museum, Montclair,
 New Jersey
 Realism Today, National Academy of Design, New
 York; Smith College Museum of Art, Northampton,
 Mass; Arkansas Art Center, Little Rock, AK; and
 Butler Institute of American Art, Youngstown, Ohio

PUBLIC COLLECTIONS
The National Museum of Contemporary Art,
 Oslo, Norway
The National Gallery, Oslo, Norway
Norsk Kulturråd, The City of Oslo, Norway
The Royal Palace, Oslo, Norway
Rikshospitalet , Oslo, Norway
Norges Bank , Oslo Norway

Norsk Statoil, Stavanger, Norway

The Municipality of Asker, Norway

Chase Manhattan Bank, New York

Chemical Bank, London

The Municipality of Norrkøping, Sweden

Arkansas Art Center, Little Rock, Arkansas

SELECTED BIBLIOGRAPHY

1993 Åsmund Thorkildsen, *Stillhetens Sprog.* "Does
Painting hold a Place for Quietness?", Kunstnernes
Hus, Oslo, Norway

1992 Gunnar Sørensen, "Samtidsbilder", The National
Museum of Contemporary Art/Aschehoug, Oslo,
Norway

1988 Susan Kandel and Elizabeth Hayt-Atkins,
"Ida Lorentzen at Tibor de Nagy", *Art news Magazine*,
v. 87, no 206, New York

1987 *SIKSI,* no 4, Nordic Art Review, Helsinki, Finland
Gunnar Sørensen, "Realism today", *The Rita Rich
Collection*, The National Academy of Design, New
York
Eva Valebrokk, *9 kunstnere*, Grøndahl, Oslo, Norway

1986 Holger Koefoed, "En realistisk linje", *Eros,*
J.M. Stenersen Forlag, Oslo Norway

HEGE NYBORG

Born 1961 in Oslo, Norway.

Lives and works in Oslo, Norway

EDUCATION

1991 National Academy of Fine Arts, Oslo, Norway

1988 Akademie der Bildenden Künste, Vienna, Austria

1986 National Academy of Arts and Crafts, Oslo, Norway

1982 BA Philosophy, Political Science, Amherst College,
Amherst, Mass.

SELECTED GROUP EXHIBITIONS

1995 *At Century's End, Norwegian Artists and the Figurative
Tradition 1880/1990*, Henie-Onstad Art Center,
Høvikodden, Norway; The National Museum
of Women in the Arts, Washington D.C; catalogue
Streets, Nordic Exhibition, Helsinki Art Hall,
Helsinki, Finland; catalogue
Lumina, QUARTAIR Contemporary Art Initiatives,
Den Haag, The Netherlands
In the League, Galleri Heer, Oslo, Norway

1994 *Dialogue with the Other*, Kunsthallen Brandts
Klædefabrik, Odensen, Denmark; Norrkøping
Museum of Fine Arts, Norrkøping, Sweden;
catalogue
BBKLN, Oslo Kunstforening, Oslo, Norway;
Bergens Kunstforening, Bergen, Norway;
Forumgalleriet, Malmø, Sweden
7 unge norske, Contemporary Art Center of Vilnius,
Vilnius, Lithuania; catalogue

1993 *Hommage*, Trondhjems Kunstforening, Trondheim,
Norway

1992 *Composite*, Oslo Kunstforening, Tegnerforbundet,
Unge Kunstneres Samfund, Oslo, Norway; catalogue

1991 *Det Syntetiske Bilde*, Kunstneres Hus, Oslo, Norway;
catalogue
The Border, Galleri Enkehuset, Stockholm, Sweden;
Galleri Pelin, Helsinki, Finland; Kunstnernes Hus,
Oslo, Norway
16 individualister, Galleri F-15, Moss, Norway
Abjekt, Nordiskt Konstsentrum, Helsinki, Finland

1990 *4 Kunstnere*, Wang Kunsthandel, Oslo, Norway
Galleri Heer, Oslo, Norway

PUBLIC COLLECTIONS

Riksgalleriet, Oslo, Norway

Norsk Kulturråd, Oslo, Norway

The National Museum of Contemporary Art, Oslo,
Norway

SELECTED BIBLIOGRAPHY

1994 *SIKSI,* no 4, Nordic Art Review, Helsinki,
Finland

HANNELINE RØGEBERG

Born 1963 in Oslo, Norway

Lives and works in Seattle, Washington

EDUCATION

1990 M.F.A Painting and Printmaking, Yale School of
Art, New Haven, Connecticut

1988 Skowhegan School of Painting and Sculpture,
Skowhegan, Maine

1987 B.F.A. Painting, San Francisco Art Institute, San
Francisco, California

1987 Yale Summer School for Painting and Music,
Norfolk, Connecticut

1982 Examen Philosophicum, University of Oslo, Oslo,
Norway

SOLO EXHIBITIONS

1994 Diane Farris Gallery, Vancouver, Canada; catalogue

1992 Southern Connecticut State University, New Haven,
Connecticut

1990 Parker Zanic Gallery, Los Angeles, California

1987 Union Gallery, San Jose State University, San Jose,
California

1986 Gallery One, San Jose City College, San Jose,
California

SELECTED GROUP EXHIBITIONS

1996 *Naked,* University of Hawaii Art Gallery, Honolulu,
Hawaii; catalogue

1995 *The Reconstructed Figure,* Katonah Art Museum,
Katonah, New York; catalogue
Two Person Project: HORIZONS, The Contempo-
rary Arts Center, Cincinnati, Ohio
*At Century's End: Norwegian Artists and the Figura-
tive Tradition, 1880/1990,* Henie-Onstad Art Center,
Høvikodden, Norway; The National Museum
of Women in the Arts, Washington D.C.; catalogue

1994 *Sacred and Profane,* Jan Baum Gallery, Los Angeles,
California
Gallery Artists, Diane Farris Gallery, Vancouver,
Canada

1993 *The Anxious Salon,* MIT-List Visual Art Center,
Boston, Massachusetts; catalogue
Reciprocities: Artists choose Artists, Baxter Gallery,
Portland, Maine
Faculty Show, Jacob Lawrence Gallery, University of
Washington, Seattle, Washington

1992 *These Painters Shaped in the Last Decade,* Gallery
Galtung, Oslo, Norway
Gallery Artists, Jan Baum Gallery, Los Angeles,
California

1991 *Synthetic History,* Parker Zanic Gallery, Los Angeles,
California

1990 *Introductions,* Parker Zanic Gallery, Los Angeles,
California
CAA Invitational Exhibition, Vorhees Gallery,
Hunter College, New York

1987 *Spring Show*, Diego Rivera Gallery, San Francisco
 Art Institute, San Francisco, California
 Bay Arts, San Mateo, California
1986 *San Jose Biennial,* WORKS Gallery, San Jose,
 California
 Statements from Within, Triton Museum of Art,
 Santa Clara, California
 Bay Area printmakers, Gallery One, San Jose, California

PUBLIC COLLECTIONS

Vancouver Art Gallery, Vancouver, Canada
San Francisco Arts Commision, San Francisco, California
Yale University, New Haven, Connecticut
San Jose State University, San Jose, California

LINE WÆLGAARD

Born 1959 in Oslo, Norway
Lives and works in Oslo, Norway

EDUCATION

1989 Konstfackskolan, Academy of Photography,
 Stockholm, Sweden
1981 Department of Law, University of Oslo, Norway

SOLO EXHIBITIONS

1994 Galleri Adlecreutz-Björkholmen, Stockholm, Sweden
1993 Galleri F-15, Moss, Norway
1992 Galleri Index, Stockholm, Sweden

SELECTED GROUP EXHIBITIONS

1995 *At Century's End: Norwegian Artists and the*
 Figurative Tradition, 1880/1990, Henie-Onstad Art
 Center, Høvikodden, Norway; The National
 Museum of Women in the Arts, Washington D.C.;
 catalogue
1994 *X–Y Identitet och position inom Nordisk Samtidskonst,*
 Åbo Kunsthall, Sweden; catalogue
1993 *7 unge norske,* The Contemporary Art Center of
 Vilnius, Vilnius, Lithuania; catalogue
 Juniutstillingen, Kunstnerforbundet, Oslo, Norway

1992/93 *European Photography Award,* Künstlerwerkstatt,
 Berlin, Germany; Englisher Kirche, Bad Homburg,
 Germany
1992 *Composite,* Oslo Kunstforening, Tegnerforbundet,
 Unge Kunstneres Samfund, Oslo, Norway; catalogue
1991 *Statens Høstutstilling*, Kunstnernes Hus, Oslo,
 Norway
 Pohjonen Valukova, Uleåborg, Finland
1990 *Fotografisk Vårutstilling*, The Munch Museum, Oslo,
 Norway; Drammen Kunstforening, Drammen,
 Norway
1988 *Futurum*, Kulturhuset, Stockholm, Sweden;
 Høgskolan i Helsinki, Finland
1987 *Simulo*, Norwegian Contemporary Art, Oslo City
 Hall, Oslo, Norway

SELECTED BIBLIOGRAPHY

1994 *Norwegian Art Yearbook 1993/94,* Oslo, Norway
1993 *F-15 Kontakt*, no 4, Moss, Norway
1992 *Index Magazine*, no 3, Stockholm, Sweden

Kristin Ytreberg

Born 1945 in Tromsø, Norway
Lives and works in Oslo, Norway

Education

1989 Academy of Fine Arts, Department of Sculpture,
Oslo, Norway
1969 Norwegian Institute of Technology, Department of
Architecture, Trondheim, Norway

Solo exhibitions

1994 Kunstnerforbundet, Oslo, Norway
1993 The National Museum of Contemporary Art, Oslo,
Norway
Tromsø Art Association, Tromsø. Norway
1992 Galleri F-15, Moss, Norway
1991 UKS, Young Artists Association, Oslo, Norway

Selected group exhibitions

1995 *At Century's End: Norwegian Artists and the Figurative
Tradition, 1880/1990,* Henie-Onstad Art Center,
Høvikodden, Norway; The National Museum of
Women in the Arts, Washington D.C.; catalogue
1994 *Høstutstillingen,* Kunstnernes Hus, Oslo, Norway

1992 *Composite,* Oslo Kunstforening, Tegnerforbundet,
Unge Kunstneres Samfund, Oslo, Norway; catalogue
Spring Exhibition, UKS, Young Artists Association,
Oslo, Norway
1991/92 *Bird Houses,* Galleri F-15, Moss, Norway
1991 *Spring Exhibition,* UKS, Young Artists Association,
Oslo, Norway
1989 *Høstutstillingen,* Kunstnernes Hus, Oslo, Norway
1986 *Høstutstillingen,* Kunstnernes Hus, Oslo, Norway
Outdoor Sculpture, Oslo, Norway

Public collections

Norsk Kulturråd, Oslo, Norway
Nordnorsk Kunstmuseum, Tromsø, Norway
Tromsø Fylkeskommune, Tromsø, Norway

Bibliography

1995 *SIKSI,* no 4/94, Nordic Art Review, Helsinki,
Finland
1994 *Norwegian Art Yearbook 1993/94,* Oslo Norway
1993 *Terskel/Threshold,* no 10, Oslo Norway
Norwegian Art Yearbook 1993, Oslo Norway
F-15 Contact, no 6, Moss, Norway

Exhibition Checklist

1 HARRIET BACKER
Fourre-tout (1881–82)
Oil on canvas, 28 ¾ x 36 ½ inches
Private collection

2 HARRIET BACKER
Music, Interior from Kristiania (1890)
Oil on canvas, 15 x 18 inches
The National Gallery, Oslo, Norway

3 HARRIET BACKER
By Lamplight (1890)
Oil on canvas, mounted on wooden plate,
14 x 17 ¼ inches
The National Gallery, Oslo, Norway

4 HARRIET BACKER
The Altar in Tanum Church (1891)
Oil on canvas, 26 ½ x 21 ¼ inches
Private collection

5 HARRIET BACKER
The Living Room at Kolbotn (1896)
Oil on canvas, 24 ¼ x 33 inches
The National Gallery, Oslo, Norway

6 HARRIET BACKER
Einundfjell (1897)
Oil on canvas, 38 ½ x 51 ½ inches
Rasmus Meyers Collection, Bergen, Norway

7 HARRIET BACKER
My Studio (1918)
Oil on canvas, 30 x 36 ½ inches
Bergen Billedgalleri, Bergen, Norway

8 KITTY KIELLAND
Studio Interior, Paris (1883)
Oil on canvas, 16 ¾ x 14 ½ inches
Lillehammer Art Museum, Lillehammer, Norway

9 KITTY KIELLAND
Blue Interior with Sitting Woman (1883)
Oil on board, 16 x 12 ½ inches
Private collection

10 KITTY KIELLAND
By the Tarn (Study) (1886)
Oil on paper, mounted on canvas, 15 x 18 ¼ inches
The National Gallery, Oslo, Norway

11 KITTY KIELLAND
Jærgård
Oil on canvas, 12 ½ x 21 ½ inches
Private collection

12 KITTY KIELLAND
Summer Evening (1890)
Oil on canvas, 11 ½ x 19 inches
Private collection

13 KITTY KIELLAND
Sunset, Tyin (1898)
Oil on canvas, 24 x 43 ¾ inches
Private collection

14 KITTY KIELLAND
Peat Bog – Jæren (1901)
Oil on canvas, 34 x 51 ¼ inches
Stavanger Museum, Stavanger, Norway

15 ASTA NØRREGAARD
Portrait of Maggie Plahte (1881)
Oil on canvas, 22 ½ x 17 inches
Private collection

16 ASTA NØRREGAARD
In the Studio (1883)
Oil on canvas, 25 ½ x 19 inches
Private collection

17 ASTA NØRREGAARD
Portrait of Edvard Munch (1885)
Pastel, 50 x 31 ½ inches
The Munch Museum, Oslo, Norway

18 ASTA NØRREGAARD
Music Interior (1885 ?)
Oil on canvas, 28 ¾ x 29 ¼ inches
The National Gallery, Oslo, Norway

19 ASTA NØRREGAARD
Woman Reading by an Open Window (1889)
Oil on canvas, 19 ¾ x 13 ¾ inches
Private collection

20 ASTA NØRREGAARD
Self Portrait (1890)
Oil on canvas, 32 x 24 inches
Oslo City Museum, Oslo, Norway

21 MARIANNE HESKE
Avalanche (1993)
Installation, video-painting on sandblasted metalplates
+ 1001 hand cast crystal doll heads, 157 ½ x 197 inches
Collection of artist

22 IDA LORENTZEN
Life Size (1994)
Oil on canvas, 89 x 114 inches
Courtesy of Babcock Galleries, New York

23 IDA LORENTZEN
To Ask is to Have Where Answer is Given (1994)
Pastel, 19 ¼ x 24 ½ inches
Courtesy of Babcock Galleries, New York

24 IDA LORENTZEN
The Empty Cross (1994)
Oil on canvas, 51 ¼ x 67 inches
Private collection

25 IDA LORENTZEN
He is Not Dead, He is Only Sleeping (1994)
Oil on canvas, 51 ¼ x 59 inches
Courtesy of Babcock Galleries, New York

26 IDA LORENTZEN
Rise Up and Your Reflection Will Attend (1994)
Oil on canvas, 53 x 67 inches
Courtesy of Babcock Galleries, New York

27 HEGE NYBORG
In the Garden of Eden (1992)
Diptych, oil on canvas with projected text,
each 17 ¾ x 53 ¼ inches
Trondhjems Kunstforening, Trondheim, Norway

Acknowledgments

The National Museum of Women in the Arts is proud to present *At Century's End: Norwegian Artists and the Figurative Tradition, 1880/1990* in cooperation with the Royal Norwegian Ministry of Foreign Affairs, Oslo, Norway, and the Henie-Onstad Art Center, Høvikodden, Norway. We also extend our gratitude to Her Majesty, Queen Sonja of Norway, for her patronage of the exhibition, as part of the 1995 Norwegian Cultural Year in the United States.

At Century's End is a landmark exhibition which thematically documents the important contributions of nine women to the development of Norwegian figurative art at the turn of the 19th century and again at the end of the 20th. By bracketing the 20th century in this rather unconventional way, we are able to see clearly the great strides that women artists in Norway have made in the past one hundred years. We also can observe how crucial their efforts have been to defining a national and international context for Norwegian art—past, present and future. Furthermore, as we review their work, we come to understand how, as artists at the cultural forefront of their respective eras, they have constantly sought to push the boundaries of public understanding of what qualifies as figurative art. The continual process of cultural reconsideration and renewal has produced significant new forms as well as new issues to consider—ideas which provide a measure of optimism for the continued social viability of the arts as our own century comes to a close.

From its inception nearly four years ago, this exhibition has been a model of international cooperation. It would not have been possible without the enthusiastic commitment and support of Geir Grung, Director General of the Royal Norwegian Ministry of Foreign Affairs, and Eva Bugge, Deputy Director General, as well as the invaluable efforts of Ministry staff members Eva Finstad, Counselor, and especially, Ellen Høiness, Executive Officer. We also offer our most sincere thanks to Ambassador and Mrs. Kjeld Vibe as well as Counselor Tore Tanum, Head of Press and Cultural Section, and Gerd Lavik, Cultural Attache, of the Royal Norwegian Embassy, Washington, D.C., for their encouragement and abiding interest in this project. We would also like to express appreciation to our partner institution, the Henie-Onstad Art Center, Høvikodden, Norway, Director Per Hovdenakk and, in particular, Curator Toril Smit, for her indefatigable assistance in all aspects of the exhibition's preparation. For the organization and display of *At Century's End: Norwegian Artists and the Figurative Tradition, 1880/1990* at NMWA, special thanks go to the museum staff, including Susan Fisher Sterling, Curator of Modern and Contemporary Art, and Brett Topping, Director of Publications.

To the contemporary artists who wholeheartedly agreed to participate in this project— Marianne Heske, Ida Lorentzen, Hege Nyborg, Hanneline Røgeberg, Line Wælgaard and Kristin Ytreberg—we offer our warmest thanks and congratulations. Our gratitude is extended as well to the public and private lenders to the exhibition, including: Knut Berg, Director, and Tone Skedsmo, Senior Curator, The National Gallery, Oslo; Alf Bøe, former Director of the Munch Museum, Oslo; Jorun Sandstøl,

Curator, Oslo Bymuseum; Per Boym, former Director of the Rasmus Meyers Samlinger and Bergen Billedgalleri; Svein Olav Hoff, Director, Lillehammer Bys Malerisamling; Trondhjems Kunstforening; Haugar Vestfold Kunstmuseum; and Stavanger Museum. Finally, we offer special recognition to: Tone Skedsmo, Senior Curator, The National Gallery, Oslo; Professor Anne Wichstrøm, Center for Women's Research, University of Oslo; Anne Christiansen Qvale, Director, Tegnerforbundet, Oslo; and Hanne Holm-Johnsen, Art Manager, Fotogalleriet, Oslo; who, along with Toril Smit, provided excellent guidance and insights throughout the planning stages of the exhibition. Thanks goes as well to Helene Haaland Mustad, ArtLink,

Oslo, Bjarne Flølo, former Cultural Attache, Royal Norwegian Embassy, Washington, D.C.; and Mr. and Mrs. Kjell Rinde for first introducing the idea of an exhibition of Norwegian women artists to The National Museum of Women in the Arts.

We feel privileged to have had the opportunity to create this exhibition which advances a new thematic understanding of Norwegian artists' achievement from 1880 to 1990. It is especially fitting that we do so during during the 1995 Norwegian Cultural Year.

REBECCA PHILLIPS ABBOTT
Director
Administration